Appreciations of Truth and Beauty

Appreciations of Truth and Beauty
by Jeffrey K. Hill

Appreciations of Truth and Beauty

"If the truth is worth telling, it is worth making a fool of yourself to tell it." — Frederick Buechner

Table of Contents

Introduction

"Thing of Beauty"

The Fight Between Carnival and Lent

The Great Gatsby

Composer of Love Notes

Apostle of the Infinite

One Hundred Years of Solitude

The Art of Painting

It's A Wonderful Wife

Conclusion

About the Author

Available Now

Colophon

Introduction

"Beauty is something we share, or something we want to share, and shared experiences of beauty are particularly intense forms of communication. Thus, the experience of beauty is not primarily within the skull of the experiencer, but connects observers and objects such as works of art and literature in communities of appreciation." — Crispin Sartwell

I have reached an age of understanding that causes me not just to see or hear something, not just to be a consumer, but to take in things and internalize them, to take account of them, to take their measure in my life and in the wide world. While I find I have done this on occasion at times past, the discipline has taken on larger and greater importance in recent years.

Everywhere we turn we can feel confronted by the worst, the ugliest, curses on us and things we would curse. What is given the most attention in the news, at our jobs, or in our homes can often distract and drive us to despair. But in the background, in the quiet, even hidden in plain sight we can find things worthy of praise, the excellent, the beautiful. Relief from our cares comes by filling our senses and focusing on things true, noble, reputable, authentic, compelling, and gracious.

To genuinely appreciate something takes time. We must pause in the middle of life to really see truth and beauty. We see them only in moments, fleeting, but repeating in different forms or circumstances. The artist notices either the moment itself, or his experience of it, and records it in a book, or song, or painting, or sculpture. That work of art becomes a time-traveling device, transporting us back to that particular moment in the past. The romantic sonnet that Shakespeare wrote, or the domestic scene that Fragonard painted, though hundreds of years old, comes to life in the present of the beholder, over and again, communicating the truth and beauty that was captured.

Exposure to truth and beauty reveals meaning in my life. Contemplation of artists and their works gives me a better understanding of myself and the world. This collection of essays fluctuates between admiration, observation, and criticism. I brought them together not because I have anything authoritative to say, but because I hope you and others might be inspired to explore a writer or artist or musician through my appreciation, and thereby discover new worlds of truth and beauty, of meaning and purpose.

"Thing of Beauty"

> *"[...] even in little things that are charming and graceful, even in the more modest beautiful things, one can find a trace of the pure and the noble frees us from captivity in our egoistic interests and undoes the fetters of our hearts, releasing us (even if only for a short time) from the wild passions that convulse them."* — Dietrich von Hildebrand

The only song that chokes me up every time I hear it is "Thing of Beauty" by Hothouse Flowers, which I first heard on WCBR 92.7FM, my favorite radio station of all time, now defunct. As I remember the legend, on 9 January 1989 the station launched its new Adult Album Alternative programming with "Thing of Beauty"; the last song played before the switch to a new format under new ownership on 14 November 1998 was "Thing of Beauty". That is likely a piece of received or invented mythologizing, but what can be stated with certainty is throughout those nearly ten years, Tommy Lee Johnston, Ken Sumka, Dave Anton, and others introduced me to some truly amazing music. They played songs that I could not hear on any other radio station—this long before the advent of satellite radio and streaming on demand—what struck me as simply quality music, ranging from rock to folk, blues to alt-country, and almost everything in between as long as it was well-crafted and essentially not Top 40. That station did a lot to form and

refine my musical tastes.

Hothouse Flowers was an Irish band, so their exposure and fame was mostly localized in the United Kingdom. Their first album, released in 1988, was the most successful debut album in Irish history. When "Thing of Beauty" was released as a single, it reached as high as #14 on the Alternative chart in the United States, in the heyday of bands like Nirvana, The Smashing Pumpkins, and Pearl Jam.

The music begins subdued, a five-note phrase repeated beneath a swirling piano, establishing a rhythm that will propel the song forward. At a headlong pace, the first verse paints a word picture of a simple winter scene of the sun shining through frost on the window. The next verse conjures another scene of moonlit emotions, but adds to it sounds of nature, which the singer vows not to ignore. They are tiny moments captured, immortalized, seized out of the steady flow of time and fixed forever in music. The chorus reminds us of beauty as it appears in so many ways all around us, after which there is a lull, only a moment for us to catch our breath before we waterfall down and are whisked forward again, because, as the lyrics say, "There is so much to breathe, see, know, understand, and do!"

Such lyrics convey a sense of wonder and appreciation for the pure and noble. This great song of beauty is a flash of radiance in a metered pattern of meaning, revealing secrets and origins and fulfillment that make sense of apparent chaos. Life begins and time flies, anchored always by a smooth steady bass line, with saxophone and piano driving an ascent through a sparkling empyrean until we

reach a place of calm and rest as the music fades out.

While I would not rate this as the best song I know, something in it that I struggle to identify or even understand elicits a raptness in me—a welling-up of sensitivity accompanied by a calming and draining of tension. It is a self-transcending emotion that simultaneously lifts me outside the moment and expands the moment toward eternity. It suggests something bigger than my self, bigger than the song itself. For me the song opened the door to worlds of truth and beauty I had never known existed, but were there just waiting to be experienced. Perhaps "Thing of Beauty" today still chokes me up because it summons a time and place that I cherished, and in many ways did not genuinely appreciate until it was gone, and because it encapsulates all of my known world.

The Fight Between Carnival and Lent

"A good work of art captures universal truths about humanity." — Benjamin Lockerd

Peter Bruegel was a master of grand-scale paintings in the anecdotal genre, yet only once did he fully rise above his talent. In this masterpiece Bruegel succeeds in creating a census-like inventory of all humanity, though it is much closer to caricature than idealization. The painting is populated with plausible, solid people, social beings set in a real urban environment instead of the utopian frameworks of other artists.

Bruegel's life history consists mainly of guesswork. Some time during the 1520s in the tiny village of Brueghel, Peter was born. As was common at the time, especially among peasants who lacked a family name, he adopted the name of his birthplace. The exact location of the Brabant village is disputed but generally attributed to one of three small towns now situated in Belgium and Holland.

Bruegel apprenticed under a number of masters in the Antwerp guild but was most influenced by Hieronymous Bosch. He worked for Bosch on many of that master's paintings, mostly contributing in the spookish scenes of drollery that were so prevalent in Bosch. The other great influence on Bruegel's work was his mother-in-law, who was an accomplished miniaturist. Bruegel himself influenced a number of painters, some of whom were his

own descendants through his two sons Pieter "Hell" and Jan "Velvet".

On 4 September 1569 Bruegel died, leaving a wealth of material, much of it with a religious theme, which would earn him the reputation as a master of literary painting. That reputation is marvelously evidenced by *The Fight Between Carnival and Lent*.

The painting is done in oil on a wood panel, signed and dated in 1559. Today it is on display at the Kunsthistoriches Museum in Vienna. There is one reproduction which is disputed. Except for two landscapes dated 1553 and 1557, and *The Blue Cloak* of early 1559, this is Bruegel's earliest work, and his most ambitious ever.

Bruegel was not the first to make an artistic rendering of the mock religious battle. Frans Hogenberg had made an etching of the fight, which was published in 1558 by Hieronymus Cock, and Bruegel used this as a starting point for his work. Both illustrate the popular late medieval comic parody of chivalric battle that was a traditional ingredient of Mardi Gras celebrations, in which Lent is defeated and sent into exile. Bruegel was not interested in the parody as much as he was in the Catholic-Lutheran struggles that were forever exploding during his lifetime. The painting is almost an all-out attack against the Inquisition's routine punishment of people who did not follow the dietary guidelines of Lent.

A panoramic bird's-eye view of truth and beauty, the painting shows people unselfconsciously alive and active. The backdrop is based on the medieval conception of space

as the two dimensions of the vertical plane. The characters form a circular arrangement from which diagonals radiate in all directions. The tapestry designs of Sebastiano Serlio influenced this structure, which Bruegel went on to use often. The topographical precision can be attributed to the influence of Abraham Ortelius, a close friend of Bruegel and a notable geographer. Ortelius said there is more thought than painting in Bruegel's work. This is easily recognizable to anyone who looks at his paintings more than once, for each time the eye is fascinated and finds new details, all of which must have taken great pains to record.

The richness to *Carnival and Lent* is evidence of Bruegel's genius. He provides minutely realistic detail in a vastly complex composition. There is a swarming sense of lively movement, integrating a host of conflicting data—both pronounced and implied, using a simple yet subtle style, with clear yet cryptic symbols that provide both familiar and strange meanings—and there is never confusion.

By being inclusive rather than exclusive, Bruegel is able to create a lifelike picture of human personalities so that one can easily visualize the characters as they were in flesh and blood. All are subject to Bruegel's brush: young and old, weak and strong, unblemished and disfigured, sad and merry, saint and sinner. He concerns himself with the daily process of living of ordinary inhabitants of a tranquil Flemish village—the ones who toil, suffer, and take their pleasures simply and anonymously, at the lowest social level—not those who shape the destinies of nations.

The simple peasants in the painting number about 170.

They are gathered in the village square, some going about their chores, but most celebrating Shrove Tuesday, a spectacular occasion in the Netherlands in the sixteenth century. The three-day festival was a public orgy of frantic eating, drinking, and carousing that preceded the forty days of Lent, a period of penitence. Mardi Gras was fiercely opposed by Catholics but favored by Lutherans who said it was a safety valve, while fasting and other piety was the hypocrisy of the Catholic church.

On the right side of the painting is Lent, a knife-faced woman dressed in mourning who Bruegel modeled after a Bosch witch. Lent is drawn on a cart by a nun and monk. In her left hand she carries a bundle of switches for scourging penitents, and with her right hand wards off her opponent with two herrings on a baker's paddle. She is followed by people who perform various acts of piety, from almsgiving to praying to burying the dead. Some, however, are busy making money or playing. Radiographic imaging reveals a corpse in the wagon which the woman draws, along with numerous other cripples, have long since been painted over.

Lent's opponent, the fat King Carnival, sits astride a beer barrel and wields a pig on a spit. He does not seem to be enjoying himself and, combined with the tragic masks worn by his followers, a sense of pity is evoked. I suspect they actually are having a great time mocking the piety and sour-faced restraint of those on Lent's side. Carnival's followers indulge themselves in eating pancakes, drinking beer, dancing, gambling, playing pranks, and making love. They ignore the cripples who can barely handle their crutches.

The only character who is obviously not a peasant is the burgher on the side of Lent. He has an expensive fur-lined black tunic, a rich purse, a prayer book in his pocket, and a soft leather cap atop hair that is cut like that of a scholar. But most importantly he has a servant, either a dwarf or boy who is carrying his church stool. The burgher has stopped to give money to a man without eyes.

Prurient gawkers enjoy *The Dirty Bride*, a comic play, derived from Virgil, being performed in front of the inn by strolling players. Across the street the play *Valentine and Orson*, a romance about twin brothers raised in opposite circumstances, is being performed, while around the corner admissions are being collected. Behind Carnival is a woman leaning over an improvised hearth to cook pancakes. On Lent's side a housewife approaches a fish stall to make her purchases.

Beggars and lepers abound, wearing foxtails, a symbol adopted by Protestant petitioners who opposed their Catholic rulers during the time of the Compromise of Nobles. The symptoms of a great number of physical and mental diseases are faithfully rendered. Experts have identified everything from spasmodic paraplegia to advanced locomotor ataxia, an outgrowth of syphilis, to maladies that waste and curl legs and result in four toes on each foot, depictions so accurate they could not be a part of Bruegel's imagination.

The couple in the center that is being led away by a fool seems essential to understanding the painting, yet they are detached from the surrounding activities. Attention is drawn to them only by their central placement. Also in the middle

of the painting is an oasis of yellow sand dappled with patches of pale green, on which the couple walks. This is a starting point for two major color schemes: grayish browns occur in the lower half while ocherous grays are displayed in the upper half. There are infinite nuances of color throughout, but Bruegel uses these two schemes to hold together the throng of motley characters.

While Bruegel does a magnificent job of displaying the topsy-turvy world of medieval Flemish village life, it is also true that *Carnival and Lent* functions on a symbolic level. Lent is representative of Catholicism, Ash Wednesday, and overzealous piety. Carnival represents the Lutheran movement, Shrove Tuesday, and the delights of self-indulgence. The two corpses on the side of Lent suggest that, if not for fear of death, no one would be charitable or religious. "Blue Boat" or "Blue Barge" was the title of societies that organized carnival revelries, and so the front building on the side of Carnival is called the Inn of the Blue Boat. The children near the church play with tops which are symbols of the need to be chastised to avoid downfall.

The battle itself seems to be even. Each side holds some advantage over the other. Virtue is with Lent but the outcome is still uncertain. A game of breaking pots among Carnival's followers pushes beyond center to Lent's side. Beyond the bakery, which is neutral because it makes both pancakes and pretzels, the line of separation stretches up the street, but is poorly defined. That is the street from which the people enter the circle of action, so followers of both sides are mixed.

Many things on the side of Lent evidence a false piety,

showing that some men are as sinful in their religion as others are in their lack of it. But supportive of Lent's cause are the trees in the background, which have a spring-like green on the right but a barren gray on the left. However, the wealthy burgher seems to be moving toward the side of Carnival, and the inn is busier than the church. Just as the eye is pulled in different directions, so is the tide of victory.

 The two people in the middle of the scene have been likened to a summation couplet. They are the only ones not overshadowed by anything. They refuse to become involved in the proceedings, seeking a different answer to the questions that haunt us all. Apart from their surroundings, they are embarked on a journey of their own, advancing together in devoted partnership. They are led by a guide who suggests that this battle will never be won, because everyone is a fool in one way or another. At the same time, they seem to be on an enlightened path, rejecting a divisive choice between two broken positions and rote practices. Bruegel shows that too much piety leads to self-importance, makes life restrictive, prohibits joy, and starves a person. Too much pleasure leads to self-indulgence, makes life meaningless, ignores suffering, and bloats a person. We must appreciate our blessings and be charitable to others, but any good thing taken to extreme produces disorder and disease. Only by choosing from each side what is most noble and pursuing the golden mean can we hope to discover truth and beauty.

The Great Gatsby

"Beauty can sail under the radar of our anxious contention over what is true and what is good, carrying along its beam a ray of the beatific vision." — Gregory Wolfe

How should we define the Great American Novel? Why has this become the blind ambition of nearly every aspiring novelist? And allowing there is such a creation, why attempt what has already been achieved? If the Great American Novel can exist, surely it is the classic and triumph of *The Great Gatsby*, published in 1925, by F. Scott Fitzgerald.

The essence of the Great American Novel is romantic—"a desperate confidence things won't last"—and Jay Gatsby is the quintessential romantic egotist. His is "an honest book" about an idealist and individual. When Dan Cody, whose name conjures the great western frontier, dies, his legacy passes to Gatsby, who becomes the representative of the new frontiersmen of wealth.

Founded by smugglers like John Hancock and freebooters like John Paul Jones, America is uniquely the self-made land of the self-made man. Gatsby is that man, sprung "from his Platonic conception of himself." He lives the American cultural myth of idealists whose dreams are all possible. His life plays out the reality and illusion of the American dream of limitless opportunity and achievement, with the sweep of America's historical adventure.

In all aspects Gatsby is full of jazz, the most American of music; but his story is more than just a history of the Jazz Age. His noble actions arise from the bright vague longing and aspiration of the individual which is a typically American emotion. The implications of that emotion build through the novel toward the final four paragraphs, in which they rise and expand to a distinct manifesto, and resonate far beyond the reading, imparting a "sense of eternity."

The Great Gatsby is not just a novel about Main Street. In form and style it is a pioneering novel, born of the desire "to write something new." It stands out like a precious gem in stark contrast to Fitzgerald's other novels, blooming with beautiful language and colored with genuine characters and scenes. Gatsby's unwavering devotion to Daisy Buchanan and the willful belief in his ability to capture a truth and beauty that are far beyond his reach, but not his imagination, at once raise him above everyday living and doom him to tragedy. Not since the Knight of the Woeful Figure determined to call himself Don Quixote de la Mancha and suffer a life in pursuit of the illusive Dulcinea has there been such a romantic character in literature.

Too many critics read the book as a condemnation of the American dream, the corruption of money and power. They, like the owl-eyed man who marvels at the heroic intensity of Gatsby's dream, see Gatsby's death as his defeat: "The poor son of a bitch." But obviously the Great American Novel cannot be about the end of the American dream. The owl-eyed man and the critics simply refuse to accept the triumphant beauty of a romantic quest.

Daisy Buchanan is funny and flirtatious. She has the

talent to sing lyrics and elicit "a meaning in each word that it never had before and would never have again". Gatsby and I both find her extraordinary and "excitingly desirable", but her husband fails to notice. Even though Gatsby sees in Daisy everything he sought far beyond himself, he is niggled by the sense that there must be something more, that every bloom will fade and wither, as the passages below reveal.

> There must have been moments even that afternoon when Daisy tumbled short of his dreams—not through her own fault, but because of the colossal vitality of his illusion. It had gone beyond her, beyond everything.
>
> [...]
>
> He knew that when he kissed this girl, and forever wed his unutterable visions to her perishable breath, his mind would never romp again like the mind of God. So he waited, listening for a moment longer to the tuning-fork that had been struck upon a star. Then he kissed her. At his lips' touch she blossomed for him like a flower and the incarnation was complete.

Gatsby is great for his persistent pursuit of life's promise. He is obsessed with awe for undying love and driven, like a visionary or prophet, to make life among the ash-heaps and millionaires "something commensurate to his capacity for wonder." In a nation which is constantly seeking something new, where agents stage events by which to search out the next Fitzgerald, Gatsby spends a brief summer of winter dreams grasping ever hopeful for "a transitory enchanted moment". He does everything he can to turn back the clock and make of his life a work of art, so

as to capture and freeze time forever.

For me, the passages that describe those enchanted moments contain the essence of poetry and are incredibly moving. Just two of the numerous instances, from different spots in the novel, show us things that are there and then almost immediately gone.

> [...] I was reminded of something—an elusive rhythm, a fragment of lost words, that I had heard somewhere a long time ago. For a moment a phrase tried to take shape in my mouth and my lips parted like a dumb man's, as though there was more struggling upon them than a wisp of startled air. But they made no sound, and what I had almost remembered was uncommunicable forever.

> [...]

> The track curved and now it was going away from the sun, which, as it sank lower, seemed to spread itself in benediction over the vanishing city where she had drawn her breath. He stretched out his hand desperately as if to snatch only a wisp of air, to save a fragment of the spot that she had made lovely for him. But it was all going by too fast now for his blurred eyes and he knew that he had lost that part of it, the freshest and the best, forever.

Though the narrator Nick Carroway warns Gatsby that one can't repeat the past, Gatsby categorically rejects the idea. When he discovers that Daisy had gone on living, even briefly, without him, his soul is nearly crushed. Gatsby could have lived and loved long and safely in the past, but his fatal conflict loomed in the present. Later, Nick reflects on this idea:

> He had come a long way to this blue lawn, and his dream must have seemed so close that he could hardly fail to grasp it. He did not know that it was already behind him, somewhere back in that vast obscurity beyond the city, where the dark fields of the republic rolled on under the night.

Upon his summer arrival in the east, Nick mistakenly believed his life was beginning over again. Through Gatsby he had to learn the truth, which the golf pro Jordan Baker already knew: "Life starts all over again when it gets crisp in the fall." Perhaps Gatsby would have been better off never to cross that threshold, always to stand upon his dock and stare across the water at the tiny green light that represented his vision, forever seeking in the accident and disconnect of his life the discovery of what philosopher Roger Scruton termed, "an emotional logic that makes suffering noble and love worthwhile."

But what does the future hold for a moralizing man like Nick Carroway? Though he realizes "life is much more successfully looked at from a single window," he seeks with focus after no grail. His life never rises to the level of art. He has little wealth, yet he enjoys the luxury of quietly forgetting one woman who was tangled in his past, and throwing over another woman from his present. Though his reservation of judgement at the start of the novel "is a matter of infinite hope", he has lost all hope by the end. Gatsby is the one who stays watching all night, who never loses hope, whose dream is incorruptible. Gatsby is the one who commits himself "to the following of a grail". Gatsby is the one who gives the novel its "melancholy beauty". Gatsby is the one who "turned out all right in the end."

Composer of Love Notes

"Some people are admirable, despite their moral defects, because their achievements display the power, the originality, and the distinctiveness—the beauty—that are essential to great works of art." — Alexander Nehamas

Leoš Janáček was born on 3 July 1854, in Hukvaldy by Příbor, Moravia, a small village below the ruins of a castle of the same name. In addition to being the most famous Czech composer of the twentieth century, he was also a choirmaster, a teacher, and the founding director of the Brno Organ School. He continued writing new music and remained active and otherwise healthy until his death at age seventy-four.

At the age of twenty-five, Janáček fell passionately in love with one of his pupils, Zdeňka Schulzová, who was only fourteen years old at the time. Two years later, in July 1881, they married; shortly thereafter Janáček changed his mind. He treated his teenage bride with increasing coldness and took no interest at all in the birth of their first child. His relationship with his father-in-law, who was also the Director of the Brno Teachers' Training Institute where he taught, were no better, and often worse. The Director even complained to the authorities about what he perceived, possibly due to Janáček's interest in folk material, to be

Janáček's nationalist fanaticism—a threat to the stability of the Austro-Hungarian Empire. Divorce proceedings were prepared, but Zdeňka was persuaded to stay with Janáček. For most of the rest of her life she regretted this decision, as Janáček conducted passionate affairs, more or less openly, with other women. With Zdeňka he had a daughter who died at age ten, and a son who died at age two. Zdeňka even once attempted suicide; Janáček reacted by meeting his mistress out of town, and then suggesting Zdeňka invite her to stay with them in their home. In the summer of 1916, the couple obtained a legal separation agreement which dissolved the duty of faithfulness and mutual help, the sharing of a common household (which they continued to do while sleeping in separate rooms), and the intimacies of marriage.

Almost every summer after 1903, Janáček went alone to take the waters and enjoy the countryside in the Moravian spa town of Luhačovice. It was there, at the age of sixty-three, some time between 3 July and 7 July 1917, he met a twenty-five-year-old woman who would become the sole focus of all his passions and erotic feelings for the rest of his life.

Kamila Neumannová was born 12 September 1891 at Putim, Bohemia. At the age of twenty she married prominent antique dealer David Stössel in Strážnice, Moravia. In her memoirs, completed in 1935, Zdeňka Janáčková recorded some of her first impressions of Kamila (all quotes being translated by musicologist John Tyrrell): "I thought she was quite nice: young, cheerful, one could have a really great talk with her, she was always laughing. She was of medium height, dark, curly-haired like a Gypsy

woman, with great black, seemingly bulging eyes […] with heavy eyebrows, a sensuous mouth. The voice was unpleasant, shrill, strident. […] She was a Czech Jew […] not particularly intelligent. She told me she didn't like going to school and didn't like learning. […] her letters were full of spelling mistakes. In music she was totally ignorant, knowing almost nothing about composers. […] She gained my husband's favour through her cheerfulness, laughter, temperament, Gypsy-like appearance and buxom body […]."

The attention Janáček paid Kamila began mostly in writing. The initial flow of correspondence was heavy. Every year of their relationship after the first saw the number of letters decrease, until the final sixteen months from which comes nearly half the total of letters. Zdeňka recalled that early in the relationship Kamila corresponded "irreproachably" with Janáček. Later, though, most of her letters were destroyed according to her wishes. Similarly, thirty-two envelopes remain empty of the letters Janáček sent to Kamila, their contents presumably too passionate for a married woman to possess.

Their early correspondence often centered on the ability of Kamila's husband to procure household supplies during the restrictions of war. Janáček also extended many invitations to the Stössels to attend performances of his works or to visit his home. These were continually declined, and the exchange of letters subsisted solely on Janáček's will. Finally Kamila accepted tickets to the German language premiere of *Jenůfa* in Vienna on 16 February 1918. When she did not send him any sort of response afterward, Janáček wrote of his disappointment. This began

a pattern of letters in which the smitten composer wondered why Kamila maintained such silence.

After eighteen months, Kamila wrote, "I felt in your company as if I were your daughter." But for Janáček there was plainly much more to their relationship than that: "you are, my dear Mrs Kamila, everything in the world to me, my one and only quiet joy, that I know of no other desire than to think about you, to get drunk on your dear cheerful presence […]." Following the second anniversary of their meeting, Janáček lost a ring during travel. He wrote to Kamila of his confidence that her "conscience and pity will answer to my misfortune and that you'll get me a new little ring for 'luck'." She responded within ten days: "I'm sending you here a little ring with my name […]." For Kamila, this was simply a gesture of good will and friendship: "I also enjoy talking with you because I know that it's innocent friendship. You write about my beauty there you're terribly wrong. […] For I'm really quite an ordinary woman of which there are thousands. […] I love my husband so much that I'd perhaps want to lay down my own head for his life. Perhaps he doesn't even know himself how I long for him perhaps just as you for me. […] I sense that love of yours for me. […] For it's beautiful that you have these memories of me that's enough for you and the main thing is so innocent. I never thought I'd correspond with some man and I resisted even you […] But fate wanted otherwise so we'll now leave everything to fate. It's better that you're so old now if you were young my husband would never permit this." It was clear, however, that for Janáček, his relationship with Kamila, and what the ring represented, was so much more than innocent

friendship. The undeniable proof came four years later when he gave her a ring of his own, to seal their belonging to one another.

Most of their meetings were either social visits involving their spouses, or in conjunction with performances of Janáček's works. For nearly three years from mid-1921 through mid-1924 there is no record of their meeting at all. Again Janáček kept the relationship alive on nothing more than his own fantasy and desire. "My life is sadder, more disordered, which is why I bind it with this 'art' of mine, I glue it together, I re-create it in my imagination more tolerably for myself. Who knows, if fate had united us closely, whether I would have needed this art, whether it would ever have made itself felt within me at all? Whether in your eyes which look on so sincerely there wouldn't have been the whole world for me?"

Janáček's visit to Kamila at Písek between 17 April and 21 April 1927 proved a turning point in their relationship. On his arrival in Prague after his visit he wrote:

Dear soul

Believe me, I cannot escape from our two walks. Like a heavy, beautiful dream; in which I am bewitched.

I know that I'd be consumed in that heat which cannot catch fire. On the paths I'd plant oaks which would endure for centuries; and into their trunks I'd carve the words which I shouted into the air. I don't want them to be lost, I want them to be known.

To no-one, ever, have I spoken these words with such

compulsion, so recklessly: 'You, you, Kamila! Look back! Stop!' and I read in your eyes as well that something united us in that gale-force wind and heat of the sun. Perhaps something was fated to give us both unutterable pleasure? Never in my life have I experienced such an intermingling of myself with you. We walked along not even close to one another and yet there was no gap between us. I was just your shadow, for me to be there it needed you. I'd have wished that walk to be without an end; I waited without tiring for the words which you whispered; what would I have done were you my wife? Well, I think of you as if you were my wife. It's a small thing just to think like that, and yet it's as if the rays of a hundred suns were overwhelming me. I think this to myself and I won't stop thinking it.

Do with this letter, this confession of mine, what you will. Burn it, or don't burn it. It brings me alive. Even thoughts become flesh.

Five days later he continued: "In the thought that I have you, that you're mine, lies all my joy of life. By it you give me the greatest happiness I've ever wished and which I never got and never really wanted from anyone before. […] I know that my compositions will be more passionate, more ravishing: you'll sit on every little note in them. […] Oh Kamila, it's hard to calm myself. But the fire that you've set alight in me is necessary. Let it burn, let it flame, the desire of having you, of having you!"

Kamila had apparently begun to give in to Janáček's ten-year siege. Though her letters have been burned by Janáček as per her instructions, his responses reveal a lingering hesitancy in her. He wrote, "And why do you fear me? Would I ever do anything to you? I'd surely never do

anything bad. And what would I do to you? I know, I know! I long for it unutterably! Is that why you're frightened? My Kamila!" He continued to remember their two walks and encourage her: "You know, Kamila, I imagine now that you're my wife […] one soul, one body! […] You're mine and I live in you. It's impossible to change anything in this. We have our world in which the sun doesn't set." And Janáček didn't hesitate to imagine their next meeting: "We'll look at each other […] and in that glance there'll be just that thought: 'we belong to each other'!"

Not surprisingly, Janáček's relationship with Kamila caused tension with his wife. When he wrote to Kamila of a typical day at home, he asked, "Can that be enough for me? Is that meant to be the happiness of life?" Zdeňka often demanded to know what was happening, and Janáček never failed to bluntly explain his feelings for Kamila. He did not try to hide anything. He wrote that Zdeňka "imagined more than was remotely possible. For surely between us there's just a beautiful world, but what's beautiful in it, these desires, wishes, the Tvá and all, all just made up! I told her this imaginary world is as necessary for me as air and water is for my life." As time progressed, Janáček called Kamila his girlfriend, then his hoped-for wife, then his wife (in quotes), then his wife (without quotes), then referred to himself as her husband, then referred to her as Mrs Dr Janáčková. "An image stands before my eyes that you'll leave what has bound you till now and I'll break what binds me. I've got such a strange premonition that it must come to this. As if some sort of flood were rising which would sweep us both away. […] Tell me, how long can it go on like this?"

In late August 1927, Janáček and Kamila again had a rendezvous at Luhačovice. This time he wrote afterward: "In my life I've not experienced more beautiful moments than those this afternoon! I'd say more exalted moments. [...] How warming were your words, how warm was your little hand which, for the first time, did not draw away." This day he continued to remember and celebrate as their "Friday-feast-day," a playful two-word rhyme in Czech.

Each year on the anniversary of the founding of Czechoslovakia, the Ministry of Education awarded monetary prizes in recognition of artistic services. In September 1927 Janáček (with *The Makropulos Affair*) was again up for the award he had already won in 1924 for *Taras Bulba*. He wrote to Kamila that "I ought to have a claim on the basis of my works; but the silence in Prague doesn't augur well for me. They'll think to themselves: 'nothing for him, he's got enough!' Yes, I have the greatest treasure, the greatest riches, but they don't know that you're the treasure, you're my wealth [...] my little soul, for me you're above everything, above all the notes that I write! You're my joy. It's only through you that I like the world. You're the holy calm in my soul, but you're also the little fire which gives warmth, which heats up desire. Everything for you. You're the source of tenderness in my compositions."

In one of Janáček's letters, he quoted something Kamila had written: "When I read those letters of yours, I blush so!" This lingering shyness had given way to an outright pledge of herself by the end of the year. Janáček replied, "And now I'll go to bed with your reassurances and my single life's wish, that you'll be wholly mine, and God grant

that with new life in your sacred womb [...]." The fantasy of Kamila's pregnancy with their child would appear several times in different forms. Then, when they met in January 1928, Kamila evidently told him she would acknowledge her love for him publicly. Janáček called her "My only desire and my future wife!"

From Janáček's letters, it seems Kamila often wavered between being completely committed to him and worrying about causing pain to their spouses, to her children, or actually breaking out of her life and into the dream Janáček continually presented to her. In one letter which has survived from March 1928, she seemed conquered and confident: "I read your letters many times, they're nice and even if I didn't want to I'd have to think of you all the time. [...] Reading your letter today I thought so much of everything past of all I've lived through and I'm happy. You remind me of it when you write how your life was before and is now. And what about mine I've not known anything else I've not longed for anything else my life just went by without love and joy. But I always went along with the thought that that's the way it had to be. Now I think that God was testing you and me and when he saw that we've been good and that we deserve it he has granted us this joy in life. If you told anyone he wouldn't believe that I've perhaps waited for you that all my life I'd found no-one who would offer me his love. I steered clear of everything I didn't look for anything and you were the only one in all the years you've known me and that really is the truth. Someone would just smile and ask how it was possible, but yes it is possible you are much dearer to me than if you were young. I can assure you that my life is pleasant that I

don't wish for any better. And for that only you are guilty. I thank you for it also." Janáček blissfully quoted another of her letters: "I'm for ever only yours."

Before going to the doctor in February 1928 to check on his health, Janáček wrote, "I'm going to be x-rayed now. What if your picture were suddenly to be found in my heart and were to leap out?! That would be fun!" Afterward he reported, "Everything healthy." The doctor had recommended he again take the waters at Luhačovice. Janáček wasted no time in devising the next plan to meet Kamila there.

When he arrived alone in Luhačovice, he wondered, "How to tempt you here!" Despite his lamentations, Kamila stayed away to tend her mother, who had become seriously ill. Only after the death of her mother did she and Janáček meet again, at Hukvaldy in the cottage he had enlarged to accommodate Kamila. There, during one of several walks through the woods, Janáček fell ill with pneumonia. A few days later he was taken to hospital in Ostrava where he died on 12 August 1928.

Late in their relationship Janáček gave to Kamila an album in which he wrote music and reminiscences of their times together. The first entry, from 2 October 1927: "So read how we have simply dreamt up our life." Janáček left the album in Písek so that Kamila could read it and remember him in his absence. At one point Janáček threatened to burn it, but Kamila persuaded him not to. She brought the album to their last meeting in Hukvaldy. The last entry, from two days before he died, reads:

And I kissed you.

And you are sitting beside me and I am happy and at peace.

In such a way do the days pass for the angels.

From their first meeting, Janáček found inspiration in Kamila for his work. "You're as necessary to me as the air. I wouldn't be what I am. None of my compositions could grow from this desert at home [...] in my compositions where pure feeling, sincerity, truth, and burning love exude warmth, you're the one through whom the touching melodies come [...]." Kamila was the gypsy in *The Diary of One Who Disappeared*; she was Elina Makropulos; she was Aljeje in *From the House of the Dead*. "And you know, when I became acquainted with you in Luhačovice during the war and saw for the first time how a woman can love her husband—I remember those tears of yours—that was the reason why I took up *Káťa Kabanová* and composed it." It was the story of a neglected wife who takes a lover. "And I always placed your image on Káťa Kabanová when I was writing the opera."

On 29 January 1928 Janáček wrote: "I've begun to work on a quartet; I'll give it the name 'Love Letters'." Two days later he added, "Now I've begun to write something nice. Our life will be in it. It will be called 'Love Letters'. I think that it will sound delightful. [...] A special instrument will particularly hold the whole thing together. It's called the viola d'amore—the viola of love. Oh, how I'm looking forward to it! In that work I'll be always only with you! [...] Full of that yearning as there at your place, in that

heaven of ours! [...] So I'm working hard—it's as if I'm living through everything beautiful once again—working on these 'Love Letters'." Excitedly, he wrote more later: "And Kamila, it will be beautiful, strange, unrestrained, inspired, a composition beyond all the usual conventions! Together I think that we'll triumph! [...] The composition will be dedicated to you; you're the reason for it [...]."

This final work was a musical record of their relationship. "The first movement I did already in Hukvaldy. The impression when I saw you for the first time! I'm now working on the second movement. I think that it will flare up in the Luhačovice heat." And then: "I'm writing the third of the 'Love Letters'. For it to be very cheerful and then dissolve into a vision which would resemble your image, transparent, as if in the mist. In which there should be the suspicion of motherhood."

He intended the first performance for Písek, the heaven where Kamila lived, but instead it occurred posthumously in Brno, with a new name. "I'm curious how my *Intimate Letters* will work. It's my first composition whose notes glow with all the dear things that we've experienced together. You stand behind every note, you, living, forceful, loving. The fragrance of your body, the glow of your kisses [...] the softness of your lips. Those notes of mine kiss all of you. They call for you passionately." After hearing a rehearsal, Janáček described, "Those cries of joy, but what a strange thing, also cries of terror after a lullaby. Exaltation, a warm declaration of love, imploring; untamed longing. Resolution, relentlessly to fight with the world over you. Moaning, confiding, fearing. Crushing everything beneath me if it resisted. Standing in wonder before you at our first

meeting. Amazement at your appearance; as if it had fallen to the bottom of a well and from that very moment I drank the water of that well. Confusion and high-pitched song of victory: 'You've found a woman who was destined for you.' Just my speech and your amazed silence. Oh, it's a work as if carved out of living flesh. I think that I won't write a more profound and a truer one."

Like Gatsby, Janáček found the truth and beauty that he sought reflected in a woman. He then went on to translate that experience, and to express his dreams of so much more, in musical composition. As he had once wondered, if fate had not denied his heart's desire, Janáček might never have sought to create anything that would transcend himself, and make his love live on.

Apostle of the Infinite

"A poet is a nightingale, who sits in darkness and sings to cheer its own solitude with sweet sounds." — *Percy Bysshe Shelley*

At the age of twenty-eight, Giacomo Leopardi wrote a letter to Count Carlo Pepoli in which he described "unremarkable facts of my life" as follows (all translations quoted from the works of J.G. Nichols, Ottavio M. Casale, and Iris Origo):

> Born to Count Monaldo Leopardi of Recanati, city of the March of Ancona, and to the Marchesa Adelaide Antici of the same city, 29 June 1798, in Recanati. Continued to live in his birthplace until the age of 24. He did not have tutors, except for the mere rudiments which he learned from pedagogues kept by his father in the household for that purpose. He had instead the use of a copious library collected by his father, a man with a great love of letters. In this library he passed the greater part of his life, as much of it and for as long as his health allowed; this was destroyed by his studies, which started independently of his tutors at the age of ten, and then went on without rest, his sole occupation. Learned, without a teacher, the Greek language, devoted himself to philological studies, and persevered with them for seven years; until, his sight being ruined, and he obliged to spend an entire year (1819) without reading, he took up thinking, and naturally grew fond of philosophy; to this, and to the related study of literature, he has since attended almost exclusively up to the present.

During a period of what he termed "mad and desperate studies," Leopardi taught himself in theology, archeology, and rhetoric; mastered Greek, Latin, Hebrew, and obtained a working knowledge of Spanish and German; translated and annotated numerous ancient literatures; wrote a history of astronomy with a bibliography of over 300 titles; and composed a hymn to Neptune in Greek which he pretended to have discovered in an ancient manuscript and which scholars accepted as genuine. He paid for this learning with his health, developing a slight curvature of the spine, moving the thorax out of place and affecting the function of his lungs and heart for the rest of his life. He also suffered swelling of the legs, insomnia, colitis, asthma, rachitis, kidney attacks, coughing of blood, dropsy, and constant problems with his sight. Depression, too, was never far off.

A guest who met Leopardi at a literary party shortly after his arrival in Florence described the poet thus: "His expression is mild, his manners gentle and courteous, but his body has a defect, the height of his shoulders. He speaks very little, is pale and seems to be melancholy." Antonio Ranieri, Leopardi's greatest friend, wrote this description: "His stature was mediocre, slight, and bent, his complexion pale; his head was large, with a broad, square forehead, languid blue eyes, a sharp nose, and fine-drawn features. His voice was low and very faint, and he had an indescribable, heavenly smile." He had erratic eating habits, a penchant for ice cream, rarely washed or changed clothes, ridiculed those he disliked however much they may have admired him, and, like the couple in Bruegel's painting, rejected both the secular hedonism of the world and the dogmatic consolations of religion.

Leopardi's system of philosophy began with man's alienation from nature. By 1824 he had shifted to believe man's suffering was inevitable. Life had taught him that "man's undeserved pain, unfulfillable longing, and monumental insignificance are not anomalies caused by alienation from nature but features built into his existence by nature herself." He developed what he termed a philosophy of despair. In the *Zibaldone* he wrote:

> The whole change in me, and the passage from the ancient state to the modern, happened one might say within a year, that is 1819, when, deprived of the use of my eyes, and of the continual distraction of reading, I began to feel my unhappiness in a much more gloomy way, I began to abandon hope, to reflect deeply on things (under the influence of these thoughts I wrote in one year almost double what I had written in a year and a half, and in subjects which concern above all our nature, unlike my past thoughts, almost all of literature), to become a professed philosopher (from being a poet), to feel the assured unhappiness of the world, instead of just being acquainted with it, and this also through a state of physical weakness, which made me less like the ancients and more like the moderns.

Over time, Leopardi formulated a concept of *noia*. This word is untranslatable, similar to boredom, spleen, or ennui in sensation, but much deeper in experience. In a letter to his brother, Leopardi likened it to "indifference, that horrible human passion, or lack of it." He expanded the concept later in his *Zibaldone*, a part notebook, part diary of some 4,500 pages covering more than fifteen years of his life, from 1817 to 1832—what biographer Iris Origo calls "a tragic record of human solitude":

> [...] In referring to the absence of pleasure and displeasure, one is referring to *noia*. [...] *Noia* always and immediately runs to fill up all the empty spaces left behind in living souls by pleasure and displeasure. The void—that is the passionless state of indifference—cannot exist in such a soul, just as it could not exist in physical nature according to the ancients. *Noia* is like the air on earth, which fills all the spaces among other objects, and races to be where they are not, unless other objects take their place. Or shall we say that the void itself in the human mind, and the indifference, and the absence of every other passion is *noia*, which is itself a passion. Now what do we mean by saying that a living being who is neither enjoying nor suffering is necessarily experiencing *noia*? We mean that he can never stop desiring happiness, that is pleasure or enjoyment. This desire—when it is neither satisfied nor directly thwarted by the opposite of enjoyment, is *noia*.

Again, in the *Operette morali*, from "Dialogue between Torquato Tasso and his familiar spirit":

> It seems to me that *la noia* is of the nature of air, which fills up all the spaces between material things and all the voids in each one of them; and whenever a body changes its place and is not at once replaced by another, *la noia* at once comes in. So all the intervals in human life between pleasure and pain, are occupied by *noia*. [...] Truly I believe that *la noia* means nothing more than a craving for pure happiness, unsatisfied by pleasure and not perceptibly wounded by wretchedness. And this craving, as we said before, can never be gratified; so that true pleasure can never be found.

Perhaps because of his physical deformities, Leopardi had little luck with women. Perhaps he subconsciously sought from all the wrong women a substitute for the love

he never received from his mother. Ranieri said that Leopardi "took the flower of his virginity untouched to the grave," and that all Leopardi's love affairs were one-sided and unnoticed by the person he loved. Despite or perhaps because of this, Leopardi believed "love could truly make a hero of me and render me capable of great things, even of killing myself."

His heart first stirred for a woman at the age of nineteen, upon meeting his cousin Gertrude Cassi. She was married, twenty-seven years old, and came to Recanati with her husband to deliver their child to a local convent school. She was a voluptuous beauty with dark flashing eyes and a warm effusive manner. She stayed only three days, following which Leopardi wrote with a Proustian minuteness and detachment of his every moment spent with her.

At age twenty-eight he become attracted to Teresa Carniani Malvezzi of Bologna. She also was married, and eleven years older than Leopardi. He claimed his relationship with her, which he described as a "tender, sensitive friendship, with a mutual interest and an abandon that is like a love without disquietude," had revived his heart "after so many years of sleep, indeed complete death."

At age thirty he encountered Teresa Lucignani, the sixteen-year-old sister-in-law of his landlord in Pisa, who Leopardi described as having "in her face, her movements, her voice, something—I know not what—almost divine that nothing can equal."

At age thirty-two he began a three-year attraction to

Fanny Targioni Tozzetti of Florence. She also was married, a lively, amorous, and pretentious woman who had the reputation for being nothing more than a commonplace coquette. Though she enjoyed Leopardi's poetry, her desire for his more handsome friend Ranieri was stronger.

Though Leopardi's loves all ended in frustration, they also inspired his creativity: he wrote "To Silvia" in honor of Teresa Fattorini, a young girl he would watch from his library in Recanati; Gertrude Cassi prompted "First Love"; Teresa Lucignani evoked "Remembrances"; and his break with Fanny Tozzetti led to the brutal ode "On the Likeness of a Beautiful Woman Carved on her Sepulchral Monument":

> That breast which made men visibly turn pale—
> These things existed once. And now you are
> But dirt and bones, a sad,
> Outrageous sight a heavy stone must hide.

Ultimately, the woman Leopardi loved best was *la donna che non si trova*—the woman who cannot be found. In her essence, this is the same woman pursued by Gatsby and Janáček. "She is one of those images, those phantoms of celestial and indescribable beauty, which we summon up between sleeping and waking, when we are little more than children. [...] The author does not know whether this lady of his—and in calling her so, he shows that he loves no one but her—was ever born, or ever will be; he only knows that she does not live on this earth, and we are not her contemporaries. He searches for her in the ideas of Plato, in the moon, the planets of the solar system, the constellations of the stars." Below is part of "To his Lady", his hymn to

this perfect woman:

> If you, my love, are one
> Of those undying forms the eternal mind
> Will not transform to mortal flesh, to try
> Funereal sorrows of ephemeral beings;
> Or if you dwell in one
> Of those innumerable worlds far off
> In the celestial swirl,
> Lit by a sun more stunning than our own,
> And if you breathe a kinder air than ours—
> Then from this meagre earth,
> Where years are brief and dark,
> This hymn your unknown lover sings, accept.

In much of his poetry, Leopardi almost cruelly stresses his philosophy that joy is nothing but the momentary subsidence of pain and that only in death can man find lasting happiness. With his poetry he consecrated his pain. But ultimately Leopardi was a firm believer in the power of imagination and the pre-eminence in our lives of illusions. With "The Infinite" Leopardi achieves what scholar Nicholas James Perella calls a "triumph of the poetic imagination over a limited reality." The Italian academic Renato Poggioli says the idyll "makes familiar and almost dear to the heart of man the alien metaphysical vision of a universe ruled by laws other than those of life and death." Leopardi's basic premise was plainly stated in "Dialogue of an Almanac-Vendor and a Wayfarer", one of the dialogues in the manner of the Greek satirist Lucian collected in his *Operette morali*: "The beautiful life is not the one we know but the one we do not know."

In a letter to Fanny Tozzetti, Leopardi claimed that

"certainly love and death are the most beautiful things in the world, and the only ones worthy of our desire." In his *Pensieri* he noted, "Death is no evil, for it frees man from all evils and takes away desire as well as the good things in life. Old age is the greatest evil, for it strips man of all pleasures, leaves him his appetites, and brings with it all pains. Nonetheless, men fear death and desire old age."

Believing nothing completed a life better, Giacomo Leopardi welcomed his death, caused by edema, on 14 June 1837 at the age of thirty-eight in the villa Ferrigni on the slopes of Vesuvius. Ranieri said of his friend, "His whole life was not a career like that of most men; it was truly a precipitate course towards death."

By sheer will, Leopardi became one of the most formidable scholars, thinkers, and writers of his time, and is considered to be Italy's third greatest poet after Dante Alighieri and Francesco Petrarca. Despite plagues of frustration brought on by poor physical and mental health, his spirit strove endlessly through poetry and philosophy to transcend the limitations he suffered, to gratify his craving for happiness, to find true pleasure, to achieve a higher glory. We see, particularly in his concept of the woman who cannot be found, that Leopardi engaged in a grail quest for something he could not describe nor discover, a truth and beauty that exists ineffable in all creation, in which he lived, sadly, and lives on, every day.

One Hundred Years of Solitude

"Humanity seems destined to oscillate forever between devotion to the world of dreams and adherence to the world of reality. And really, if this breathing rhythm of history were to cease, it might signal the death of the spirit."
— *Franz Roh*

My introduction to Gabriel García Márquez, and to the style termed Magical Realism, came in 1988 with the publication of his novel *Love in the Time of Cholera*. I enjoyed it greatly, touched by the love story and enchanted by the everyday "magic." Based on that experience, I decided to try his proclaimed masterpiece *One Hundred Years of Solitude*. Although I prefer the lighter touch and tighter focus of *Cholera*, *Solitude* has many aspects to recommend itself, and can indeed be considered a landmark literary achievement.

One Hundred Years of Solitude has been variously classed myth, biography, and history. I find aspects of all these, and others, in the book. What one can say without dissent is that it is a wonderful and popular read not at all dependent upon a knowledge of the history or politics described. This has certainly helped it to become what critic Gerald Martin has called, "The first truly international bestseller in Latin American publishing history." Mostly for this book, first published in 1967, did García Márquez receive

the Nobel Prize for Literature.

Despite its warm reception outside Latin America, many Western audiences have yet to truly understand the novel and the style in which it is written. Our emphasis on science and logic ignores a real and potent strain of enchantment that runs through our daily lives. *Solitude* is filled with these every day miracles. But the term Magical Realism is misleading at best. To draw a line between fantasy and reality is to misunderstand the novel completely. Everything García Márquez presents is genuinely real, but seen with a new (to Westerners) perspective. In fact, everything in the novel could more accurately be described as fantasy, because that is the perspective with which García Márquez has us view life. In an interview with Miguel Fernandez-Braso in 1969, García Márquez said, "My most important problem was to destroy the line of demarcation that separates what seems real from what seems fantastic. Because in the world that I was trying to evoke, that barrier didn't exist." *Solitude* therefore erases the dichotomy between reality and imagination, history and myth, memory and prophecy. The book itself blurs the boundaries between popular consumerist fluff and enduring literary art. To categorise *Solitude* as Magical Realism is lazy and denigrates the Latin American experience of life, forcing it to conform to Anglo-American norms. This novel and others of the same style are more precisely described by writer Alejo Carpentier's term "the marvelous real."

A fine example of the blending of history and myth (and the precise and sincere narrative tone in the novel) is the aftermath of the banana workers' strike. The government summons the workers to a meeting. One of the main

characters of the novel, José Arcadio Segundo, is among the workers:

> Next to José Arcadio Segundo there was a barefooted woman, very fat, with two children between the ages of four and seven. She was carrying the smaller one and she asked José Arcadio Segundo, without knowing him, if he would lift up the other one so that he could hear better. José Arcadio Segundo put the child on his shoulders. Many years later that child would still tell, to the disbelief of all, that he had seen the lieutenant reading Decree No. 4 of the civil and military leader of the province through an old phonograph horn. It had been signed by General Carlos Cortes Vargas and his secretary, Major Enrique García Isaza, and in three articles of eighty words he declared the strikers to be a "bunch of hoodlums" and he authorized the army to shoot to kill.

Just such an atrocity occurred in Colombia's history. And just as in the novel, the government denied the event ever happened and the victims ever existed. Such a thing seems more like fiction to an Anglo-American audience, but it is indeed horribly true. Governments do deceive, inveigle, and obfuscate in their own interests.

That brutal episode aside, there is something clearly magical about Macondo. It is a state of mind as much as, or even more than, a real geographical place. To further underscore the difference in the perspective of García Márquez, the inhabitants of Macondo are unfazed by things that seem plainly supernatural in the Western world, such as a flying carpet or levitation by means of chocolate; but when they encounter electric buses, movies, phonographs, and telephones, they struggle to recognize the boundaries of reality.

In general, the history of Macondo follows a linear development, from its Edenic founding, through the military struggles as it becomes integrated into the rest of the world, to its invasion by technology and civilization, and ending with its decadence and physical destruction. There is clearly a line connecting definite points in history, beginning with the exploration of Sir Francis Drake and continuing until the banana workers' strike. But this line inscribes a circle. Úrsula, the central female character, is repeatedly struck by the conviction that time is going in a circle and events are repeating. Pilar Ternera observes that "the history of the family was a machine with unavoidable repetitions, a turning wheel that would have gone on spilling into eternity were it not for the progressive and irremediable wearing of the axle." In the case of the room of the gypsy Melquíades, "it was always March there and always Monday." And the very first sentence of the novel is constructed such that past, present, and future all exist at once, with time flowing out in every direction. Indeed, the novel is multilayered, telling many stories of many characters often all at once, as if they coexisted all at once. I have found the best way to read and understand the book is to digest it in individual episodes that follow characters and thoughts with no regard at all for time.

Some of my favorite episodes in the novel are the trickle of blood, the shower of flowers, and the discovery of a monster or fallen angel or the Wandering Jew. Embedded within the episodes are also synopses of several of the author's short stories.

Many people recognize in the novel a central Oedipal plotline veined with a theme of solitude. At the start of the

book, the founders of Macondo are familiar with their family history, how their relatives had produced a male child with a pig's tail. This tail was a badge of solitude and an integral part of the son as a human. When the tail was removed, the son died. This episode of the past is actually a future (or prophecy) which never comes about, despite the fact that the Buendías eventually lose track of their history, and the last couple has no idea how closely related they are. When pressed on the subject of the novel, García Márquez has said that he really wanted to write a book about incest. And so it is that incest becomes the ultimate solitude of the Buendías and ends the family and the town.

The men and women of the Buendía family become the two sides of the marvelous real in Macondo. It is here that the line is most clearly drawn between the fantasies of the men and the realities of the women. Yet they all eventually resign themselves to the failures of their efforts. It is their very acts of resignation that condemn them to solitude of every kind. There is fearful solitude, terrible solitude, miserable solitude, and bitter solitude; a shell of solitude, an aridity of solitude, a cloister of solitude, and a pox of solitude; a solitary bed, a solitary vulture, a solitary chestnut tree, a solitary vocation, a solitary meditation, a solitary window, and solitary frustrations, streets, and hours; there is the solitude of death (which is nothing compared to the solitude of living!); there is a pact with solitude, and even accomplices in solitude. Despite all this, Úrsula believes the downfall of the Buendías can be attributed simply to war, fighting cocks, bad women, and wild undertakings.

The novel is also full of allusions to the Bible. Some interpretations are based on the presumption that *Solitude* is

a reworking of the book of Genesis. Macondo is initially a paradise in which no one dies. The inhabitants suffer numerous plagues. One of the women ascends bodily into the clouds. A storm of biblical proportions annihilates the town. The discovery of a Spanish galleon in the middle of the jungle elicits thoughts of Noah's ark. And throughout the novel there is an implicit acknowledgment of the power of namery. When Macondo is still a village, many things are yet to be named. Later, a plague of insomnia is combated by inscribing the names of things and their purpose, and the inhabitants realize they are "living in a reality that was slipping away, momentarily captured by words [...]." By far the most potent example is the names of the characters, which repeat incestuously and doom the characters to the events of their predecessors.

But something else is happening here. Near the end a priest seems to know what is going on, as he tells Aureliano Babilonia, "It's enough for me to be sure that you and I exist at this moment." So what exactly does he mean?

In 1965, García Márquez withdrew to the study of his Mexico City home and essentially remained there for eighteen months until he had overthrown a three-year reign of writer's block with the thirteen-hundred page manuscript for *One Hundred Years of Solitude*. In his novel, the gypsy Melquíades acts in exactly the same manner to create a mysterious quadruple-coded manuscript. There is another famous novel concerning one Don Quixote which is purported to be a translation of an Arabic manuscript, which mirrors life much like *Solitude*, and in which the author refers to himself. Readers of either book can easily find a copy in English, and thus treat themselves to an extra layer

of decoding. For the Buendías, the task of deciphering and understanding the manuscript of Melquíades is not so simple. Generations pass and histories are forgotten before Aureliano Babilonia finally succeeds.

At the precise moment when Aureliano Babilonia discovers he is only a character in a manuscript, I realize that the narrator is not outside the novel but within. I survive (though not forever!) to share my appreciation of this fabulous novel. But the self-knowledge Aureliano Babilonia gains means the end of his family and town.

> [...] he began to decipher the instant that he was living, deciphering it as he lived it, prophesying himself in the act of deciphering the last page of the parchments, as if he was looking into a speaking mirror. Then he skipped again to anticipate the predictions and ascertain the date and circumstances of his death. Before reaching the final line, however, he had already understood that he would never leave that room, for it was foreseen that the city of mirrors (or mirages) would be wiped out by the wind and exiled from the memory of men at the precise moment when Aureliano Babilonia would finish deciphering the parchments [...].

It has all been like a dream, seemingly so real when we are in it, until we wake to discover the dream-us doesn't really exist, and it all vanishes.

How does one interpret this novel then? Literary theorist Brian McHale has posited that "a character's knowledge of his own fictionality often functions as a kind of master-trope for determinism—cultural, historical, psychological determinism, but especially the inevitability of death [...] being the puppet of playwright and director is a

metaphor for being the puppet of fate, history, the human condition."

But Aureliano Babilonia never dies. He remains in the room, reading about his end, as the city of mirrors is swept away by a warm wind "full of voices from the past, the murmurs of ancient geraniums, sighs of disenchantment that preceded the most tenacious nostalgia [...]."

Melquíades had been through death, but returned "because he could not bear the solitude." He was the first one to die in Macondo, and was buried there. "He was a fugitive from all the plagues and catastrophes that had ever lashed mankind. He had survived pellagra in Persia, scurvy in the Malayan archipelago, leprosy in Alexandria, beriberi in Japan, bubonic plague in Madagascar, an earthquake in Sicily, and a disastrous shipwreck in the Strait of Magellan." The one hundred years of solitude are his.

A person who exists in solitude also exists outside of time. Melquíades claims to have discovered the means to immortality—it is that of written memory. He is a prophet because he is an author; he knows what will happen because he writes it. His name itself, based on a Hebrew root combined with a Greek suffix, leads, according to Kabalarian wisdom, to writing as a more natural mode of expression than the spoken word.

Critic Alicia Edwards has made another enlightening observation. She draws a comparison of the text within a text to a set of Chinese boxes. Though it is readily accepted there could always be another box inside, creating an infinite history, one rarely explores the possibility of

another box outside. With our new Latin American perspective on reality, can we begin to imagine that García Márquez and his readers are merely characters in a much larger text written by a much greater author? Wow, I am boggling my own mind!

Let me suggest one more interpretation. Author Milan Kundera has said that all his books are basically transcripts of the discourses he has with the characters he creates. It is possible García Márquez has done this, one step removed, through Melquíades. What Úrsula sees as the wild dreaming of the men is their struggle to be alive, to somehow escape the text. Whereas the women are docile and accept their fate as characters in a book, the men attempt to rebel against their author. Indeed, as the book progresses, the women no longer see Melquíades, and they think the men are talking to themselves when they are really talking with him. But try as Melquíades might, García Márquez makes certain that Macondo and the Buendías are not "exiled from the memory of men" as the massacre of the banana workers has been. For this we should all be grateful.

I prefer to read *One Hundred Years of Solitude* as a demonstration of the magical ability of writing to reveal a reality full of beauty and truth that exists beyond our understanding, but evident when we open our eyes and ears and heart.

The Art of Painting

"Art is the way we speak the meaning of our lives." — Andrew Klavan

I have often found myself contemplating the art of Johannes Vermeer. Contemplation, much like the scenes the artist depicted, is a personal and introverted activity. The idea that I should move my thoughts out of my mind, extroverted into words, print, the world, gave me pause and doubt. What did I, an obscure author with no training in sixteenth-century painting, have to say about Vermeer that already had not been said by eminent experts? From the world-famous Rijksmuseum in Amsterdam, the Head of Fine and Decorative Arts, Gregor J.M. Weber, wrote to mark the colossal Vermeer exhibition in 2023, "There will never be a final word on Vermeer." So, I add my own words to the unending flow.

My first exposure to Vermeer was unknown to me at the time. A board game that I played as a child, called Masterpiece, featured paste-card reproductions of classic paintings, among which was a youth in a fuzzy red hat, who I thought was a boy. Only many years later did I discover that the painting was *Girl in a Red Hat*, by a painter who I had since encountered and learned by name.

Through the haze of indefinite memory, I suspect I noticed the *Girl With a Pearl Earring* on a cover of a novel of the same name, written by Tracy Chevalier. I enjoyed

reading, I recognized appealing cover art, I had already gained an appreciation of classic art through a board game, and, not the least, the girl was pretty. I read the book; I learned about the painting and the artist. Understanding myself, I probably looked up other examples of Vermeer's work, though I don't recall any specifics.

Some time in the early 2000s, I watched a film called *All the Vermeers in New York*. Overall, I did not find the film entertaining, and it was done in a style that felt, at times, pointless, though some scenes seemed to be based loosely on the epic novel *In Search of Lost Time*, by Marcel Proust. But something in the film struck me, even compelled me years later to watch it again. It awakened in me a growing sense of appreciation for Vermeer. One static scene in particular mimics Vermeer's style. I looked over the catalogue of existing paintings attributed to Vermeer, and printed and framed my favorites—*Girl with a Pearl Earring*, *The Art of Painting*, and *Young Woman with a Water Pitcher*—to have hung in my own home. I bid on and purchased a lot of art books on Vermeer to increase my study and extend my appreciation. At last I began to look closely and to try, informed by the detailed technique of Vermeer and Proust, to analyze what exactly in these paintings moves me so.

Viewed as a whole, the four earliest extant works stand out as different from the rest. In the art world the first three paintings are said to fit in the history genre, with the fourth being somewhat transitional to the domestic subjects in which Vermeer excelled. Vermeer is often claimed to be the past master of light, and it is in this I find his first four works lacking, though each contains some hint and

foreshadowing of his coming excellence. In *The Procuress*, I notice two different depictions of hands, suggesting the development of the painter's powers. An officer drapes his arm around his purchase, resting on her breast a sort of blob of a hand that also seems somewhat deformed by the glass in front of it. In contrast, the prostitute's hand, held out to accept her customer's coin, is rendered delicate and unique, open yet with fingers pressed together, a living rather than a painted hand. The tiny coin itself, in the center of the painting, provides the critical hinge between events before and after the moment captured by Vermeer.

Three other paintings also bring together the figures of an officer and girl. They introduce many of the elements that Vermeer will put to regular use, such as a window, map, table, chairs, tiles, books, and musical instruments, as well as the perspective which some critics attribute to the use of a camera obscura or similar device. I notice Vermeer begins to refine the presentation of light, and he uses reflections and shadows to create space that contemporaneous paintings of the same style and subject often lack. In *Girl with a Wine Glass*, the dress of the girl fills a large chunk of space and suggests the drapes and carpets Vermeer will more often use to separate or reveal a scene. The window and panes are painted with great detail in patterns that to modern eyes look almost Cubist. The decanter on the table shimmers and shines with a bright blue-white hue.

The musical pursuits of both individuals and groups provide the subject for numerous paintings. Among them, *The Concert* is a trio in the act of making music together. Most of Vermeer's common props are included in this scene. The woman singing on the right is painted rather like

a posed angel or icon, especially compared to the girl on the left at the virginal, who is focused and quite true to life. In *The Music Lesson*, we view a couple from across a room, as indicated by the double set of windows, the expanse of large-tiled floor, and the heavy carpet that covers the table in the foreground. The man stands beside a large virginal watching a lady play. I often thought the turn of the lady's head to the right, as seen clearly by her face in the mirror, was off; but upon more careful consideration of her whole body, rather than just her face, it appears that she is indeed oriented to the right. On the wall directly in front of the lady is a mirror, and close inspection reveals the reflection of the legs of an easel, which many viewers take as a hint to the artist's hidden presence beyond the scene.

 A common motif in several other paintings is the receiving, reading, writing, or pondering of a letter. One of them, *Woman Writing a Letter, with her Maid*, depicts the servant waiting, probably to deliver the letter being written, with nothing to do but gaze out the window, her presence, almost appropriately, like a prop. What makes her waiting even more challenging, perhaps, is that the lady has already begun writing one letter, and then discarded it crumpled on the floor, to begin writing another; or perhaps in rejection she crumpled a letter received, and is dashing off a rebuttal or correction which needs be delivered back by the servant immediately. Vermeer also produced two different paintings of a woman in the act of reading a letter, this scene being replicated in the film *All the Vermeers in New York*. The later painting, *Woman in Blue Reading a Letter*, is a mid-range view of a space with which we are familiar, that includes a map on the wall, chairs, and a table covered by a

rug between the woman and a window which we cannot see. She reads with an arresting, open-mouthed expression, holding the letter along its edges just below the top with both hands, the folds in the paper clearly visible. What stands out to me is the rod from which the map extends, especially the way it and the wall behind both reflect the blue of the chair and the woman's dress in differing shades and shadows. The earlier painting, *Girl Reading a Letter at an Open Window*, is a view revealed from behind a drape. The girl, resembling and dressed as one earlier visiting with an officer, holds her letter more loosely, though still with both hands on either side further toward the end of the paper. Is the letter from that officer, telling her he is going away? The outstanding feature is the spectral reflection of her face in the window panes, and other objects and colors and shadows seen through the glass.

Six more paintings show us other women alone in various domestic activities. I consider *The Milkmaid* to be one of his best works—a woman carefully pouring milk from a jug into a bowl, the endlessly fascinating stream frozen for all eternity. Arranged on the covered table is also a jar, a basket of bread with bits broken around it, and a towel, all rendered with precise detail. *Woman Holding a Balance* stands out for the strings of jewels dangling out of their box, and the fine representation of the balance, held delicately with two fingers by the woman. Her face is infused with a saintly expression as if she had come to life from out of the painting of the Last Judgement depicted on the wall behind her.

Though Vermeer preferred women as subjects, he also produced a pair of paintings featuring a man as *The*

Astronomer and as *The Geographer*. Though their surroundings look familiar, they represent not a life of daily domestic routines, but the pursuit of science and learning. I view the first man as contemplating the mysteries of the luminaries of the heavens, and the second man captured in the moment that he realizes the globe model (which is relegated to the top of a cabinet at the back of the room) is false and the earth measured out on the charts that lay before him is truly flat. While these two paintings suggest to us the wider world that exists beyond the walls that Vermeer normally painted, he does offer us two exterior views of his time and place. The first is known as *The Little Street*. Though scholars have concluded with some certainty the actual location of these houses in Delft, I enjoy imagining this main house to be a representation of Vermeer's own, with the little passageways along the left before city renovations removed the adjoining structure. Though in function the design of certain parts of the house seem odd, the rendition of bricks and street and roofs and windows and clouds and people make it all appear true. *View of Delft* is a broad cityscape across the main canal, where several tiny people wait beside a barge. Though lacking faces, these people are painted with such attention to detail to appear stunning and real. Once again Vermeer accurately represents the way this scene is illuminated, especially in the clouds and reflections of buildings in the rippling water.

 Vermeer produced four smaller paintings that in my mind may be grouped as close-up portraits. *Girl with a Pearl Earring* is to me a supreme accomplishment, which really sparked my earliest enthusiasm for Vermeer. His

gorgeous subject seems to glow, and her clothes and headdress give her further definition against the dark background. Her lips are eminently kissable, and her gaze is alluring. While some critics take issue with the way Vermeer painted her nose, I see it rather a display of his skill with using light and shadow to render reality. Her pearl shines with a glob of light while reflecting her collar, which is also shaded in turn by the earring.

Two larger works from the brush of Vermeer remain. One is *Allegory of the Catholic Faith*, which mixes traditional Vermeer elements with those of the religion to which he likely converted as a requisite or result of his marriage. The scene is plainly not taken from real life and meant to be viewed and interpreted figuratively. The two highlights for me are the emblem painted on the globe, and the glass sphere hanging from the ceiling which reflects other parts of the room that we cannot see, like a glimpse of a backstage behind the curtain. The last painting combines many of the most common elements together in their most effective use, resulting in a masterpiece, *The Art of Painting*. Indeed, some scholars believe Vermeer produced and retained this large canvas as a sort of showpiece to be displayed in his home or workroom as an example to prospective clients of his work. The scene is again revealed to us by a curtain drawn back, but this time we see a woman posed for an artist who is in the process of painting her. We see carpets, tiles, table, chairs, and also the easel which was glimpsed in reflection in another painting. On the table is a mask and a folio laying open and angled for the artist to consult with ease. On the background wall is a large map edged with various cityscapes, all done with great detail and

individuality, including the rods and nails from which it hangs. The elegant woman is dressed as Clio, the muse of History, holding a book and trumpet, and wearing a feathered crown, seeming almost three-dimensional, standing out from the background. The artist's clothing and hair is incredibly realistic. A brilliant representation of Vermeer's style and skill is the chandelier, which shines and sparkles in light and shadow, and reflects the scene surrounding and below. This is a masterwork that extends far beyond mere allegory into a near-photographic record of the painstaking hard work of study and preparation and dedication to detail pursued by Vermeer, all coming together in a moment that suggests the creation of the painting itself.

 The subjects and settings Vermeer painted were often remarkably similar to those of his contemporaries. Paintings from the likes of Pieter de Hooch often show a sketchy technique, reminding me of book illustrations, while Vermeer's technique is far richer and strikingly elegant. What sets Vermeer apart from others is that he does not paint something like a pearl necklace, he paints colors and light which, when viewed, have the appearance of a pearl necklace. Something like a wall is not just an expanse represented in one way, but a patchwork of shadows and reflections and shades that make it seem real. His paintings have changed the way I try to view the world around me, looking not only at objects but how the light appears on them. One day I removed my glasses and realized I saw things the way Vermeer painted. The books on my shelf looked like sections of various color and light, just as Vermeer painted still lifes or maps or other elements. An

entire room looked as if it had been produced by his brush. Vermeer painted not just the things we see, but the way we see them.

 Little is known about the life of Vermeer. He sold few works during his career. He never knew the fame and fortune his paintings would one day bring. Though family and friends and fellow painters must have considered Vermeer a failure when he died, deeply in debt—indeed, his work was overlooked if not completely forgotten for hundreds of years—who today would not call him a success? Much of this can be attributed to his attention to detail, his striving for excellence, his determined search to capture forever and showcase moments infused with truth and beauty that might otherwise have been missed. He dedicated much of his life to recording his own experiences of serenity and simplicity so that today we can take part in them. The often ambiguous and unspecified circumstances of his domestic scenes leave a gap in the story that we, as observers, fill with our own thoughts, hopes, and struggles, enabling us to experience the moment ourselves.

 The novelist Marcel Proust once stated that Vermeer had been his "favorite painter since the age of twenty." The uncommon exactness with which Proust wrote compares favorably to Vermeer's style and approach to painting. As a small homage, Proust attributed to Charles Swann, one of the characters in his novel, the desire to write a life of Vermeer, which he never completes. Proust also adapts his own experience of the painter to another of his characters, Bergotte, in the following passage, a moving and majestic tribute, as translated by Scott Moncrieff.

But one of the critics having written somewhere that in Vermeer's *View of Delft* (lent by the Gallery at The Hague for an exhibition of Dutch painting), a picture which he adored and imagined that he knew by heart, a little patch of yellow wall (which he could not remember) was so well painted that it was, if one looked at it by itself, like some priceless specimen of Chinese art, of a beauty that was sufficient in itself, Bergotte ate a few potatoes, left the house, and went to the exhibition. At the first few steps he had to climb he was overcome by giddiness. He passed in front of several pictures and was struck by the stiffness and futility of so artificial a school, nothing of which equalled the fresh air and sunshine of a Venetian palazzo, or of an ordinary house by the sea. At last he came to the Vermeer which he remembered as more striking, more different from anything else that he knew, but in which, thanks to the critic's article, he remarked for the first time some small figures in blue, that the ground was pink, and finally the precious substance of the tiny patch of yellow wall. His giddiness increased; he fixed his eyes, like a child upon a yellow butterfly which it is trying to catch, upon the precious little patch of wall. "That is how I ought to have written," he said. "My last books are too dry, I ought to have gone over them with several coats of paint, made my language exquisite in itself, like this little patch of yellow wall." Meanwhile he was not unconscious of the gravity of his condition. In a celestial balance there appeared to him, upon one of its scales, his own life, while the other contained the little patch of wall so beautifully painted in yellow. He felt that he had rashly surrendered the former for the latter. "All the same," he said to himself, "I have no wish to provide the 'feature' of this exhibition for the evening papers." He repeated to himself: "Little patch of yellow wall, with a sloping roof, little patch of yellow wall." While doing so he sank down upon a circular divan; and then at once he ceased to think that his life was in jeopardy and, reverting to his natural

optimism, told himself: "It is just an ordinary indigestion from those potatoes; they weren't properly cooked; it is nothing." A fresh attack beat him down; he rolled from the divan to the floor, as visitors and attendants came hurrying to his assistance. He was dead. Permanently dead? Who can say? Certainly our experiments in spiritualism prove no more than the dogmas of religion that the soul survives death. All that we can say is that everything is arranged in this life as though we entered it carrying the burden of obligations contracted in a former life; there is no reason inherent in the conditions of life on this earth that can make us consider ourselves obliged to do good, to be fastidious, to be polite even, nor make the talented artist to consider himself obliged to begin over again a score of times a piece of work the admiration aroused by which will matter little to his body devoured by worms, like the patch of yellow wall painted with so much knowledge and skill by an artist who must for ever remain unknown and is barely identified under the name Vermeer.

It's a Wonderful Wife

"Contact with an environment permeated by beauty not only offers real protection against impurity, baseness, every kind of letting oneself go, brutality, and untruthfulness; it has also the positive effect of raising us up in a moral sense. It does not draw us into a self-centered pleasure where our only wish is to indulge ourselves. On the contrary, it opens our hearts, inviting us to transcendence [...]."
— *Dietrich von Hildebrand*

One Christmas past, I happened to be exposed to a television broadcast of the 1947 black-and-white film *It's A Wonderful Life*. In those days it was on heavy rotation, and was hard to miss. I didn't fully appreciate it until I had a few more dedicated and focused viewings, after which I made an effort to watch it every year, whenever I could, even to the point my family would tease me about how often I watched the same movie. I can tell you it's that good.

When I came of an age at which wife and children were important to me, I gained a new appreciation of the film. In particular I noticed the character of Mary Hatch, who becomes the wife of the main character, George Bailey. At first, I had a strong sense that she was the kind of woman I wanted for a wife. Then, years after repeated viewings from

this perspective, one line near the opening of the final scene revealed to me the key to my entire experience and interpretation of the story. "Mary did it, George! Mary did it!"

Plots are designed on purpose to be like roller-coaster rides, repeatedly alternating between a build-up of seemingly insurmountable conflict, followed by resolution. When I began to look at this film through the lens of that single line, I could see very clearly that every resolution, every breakthrough, every advance in the life of the main character actually hinged on Mary.

George grew up with Mary for most of his life. She was about four years younger than he was, always somewhere in the background of George's youth, and always with her heart set only on him. But from youth into adulthood, George had other interests. He tells Mary that he has a whole hatful of wishes, and he has his life planned out. "I'm shaking the dust of this crummy little town off my feet and I'm going to see the world. Italy, Greece, the Parthenon, the Coliseum. Then I'm going to go to college and see what they know. And then I'm going to build things. I'm going to build air fields, and I'm going to build skyscrapers a hundred stories high. I'm going to build bridges a mile long."

Even as he has such grand designs, we see he has a soft spot for Mary. He tells her that if she wants the moon, he will throw a lasso around it and pull it down for her. As a child, she swore she would love George forever. Her secret wish is to marry him and live together in the old abandoned Granville house at the end of town. George's mother says

that Mary is the kind of girl who will help him find the answers to life's questions. The problem is that she is just a fancy distraction from George's grandiose dreams of important things, which he can't really permit himself. He feels that over and over through his life he has been asked or forced to do things for others, to satisfy them rather than himself, and he is quickly tired of it and determined to assert himself.

After college, Mary comes back to the "measly, crummy old town" of Bedford Falls instead of going to New York where so many others have gone—basically she wants to be where George is. She tries to make him comfortable, to conjure fond shared memories, to shine a light on the path she would like him to take. He wants her, but he knows she means giving up all his dreams. When he is offered the chance of a lifetime—whether a lucrative job or an amazing wife—he blurts out, "Now you listen to me! I don't want any plastics! I don't want any ground floors, and I don't want to get married—ever—to anyone! You understand that? I want to do what I want to do." The truth and beauty of Mary, however, is too much for him to resist. Despite himself, he does not pass the chance that Mary offers.

Their marriage coincides with the onset of panic that launches the Great Depression. She rescues the Bailey Building and Loan Association from bankruptcy with the money they have set aside for a honeymoon. While George keeps the business open, she enacts an alternate plan, enlisting George's friends to help her transform the old Granville house into a makeshift honeymoon suite. The script describes this scene: "The house is carpetless, empty

—the rain and wind cause funny noises upstairs. A huge fire is burning in the fireplace. Near the fireplace a collection of packing boxes are heaped together in the shape of a small table and covered with a checkered oil cloth. It is set for two. A bucket with ice and a champagne bottle sit on the table as well as a bowl of caviar. Two small chickens are impaled on a spit over the fire. A phonograph is playing on a box, and a string from the phonograph is turning the chickens on the spit. The phonograph is playing 'Song of the Islands'. Mary is standing near the fireplace looking as pretty as any bride ever looked." When George walks in to her awaiting, it is Mary's wish come true.

Mary proceeds to assist George in his work, helping families move into new homes funded by Bailey Building and Loan, and blessing them. In the meantime, she begins the massive effort of converting the old Granville house into a home. When George is once again wracked by doubt and a sense of failure, he questions Mary, knowing she could have married anyone she wanted. She says if she hadn't married George, she would have ended up an old maid, because she wasn't interested in anyone else.

Time passes. The script summarizes, "Mary had her baby, a boy. Then she had another one—a girl. Day after day she worked away remaking the old Granville house into a home. [...] Then came a war. Mary had two more babies, but still found time to run the USO."

One day, George's uncle Billy manages to lose a bank deposit of $8,000. They search everywhere but can't find it, and George knows that, aside from the financial impossibility of making it up, the loss means bankruptcy,

scandal, and prison. George spirals back into his old depression, deeper than ever before. Mary is patient and trying to understand but when George doesn't open up and continues to berate others, including their children, she will not stand for it. George storms out, and Mary tells her children to pray as she springs to action.

George sets out to kill himself but meets his guardian angel, who grants George a wish to see what the world would be like if he had never been born. Everything around him is hard and cold and foreign and sad and depressing. As bad as things seemed before, George sees they could be so much worse. After witnessing several horrifying scenarios, George finally realizes only one thing is necessary and worth being concerned about: Mary. He discovers her without him as an old maid, just as she said she would be, entirely lacking any joy and zest for life. A bank deficit, an arrest warrant, a drafty old house, a lifetime of forsaken dreams—nothing seems bad any more. All George needs is Mary; Mary has made his life, and she is all that is good in it.

While George has had this awakening with his guardian angel, Mary has been out about town searching for him and enlisting the aid of others. Everyone George knows comes rushing to his aid, gathering at his house, and offering him all the money they have to cover his bank deficit. Mary calls it a miracle. Publicity materials for the film proclaim the lesson that no man is alone who has friends. Uncle Billy declares the truth: "Mary did it, George! Mary did it! She told a few people you were in trouble and they scattered all over town collecting money. They didn't ask any questions —just said: 'If George is in trouble—count on me.' You

never saw anything like it."

Mary is not your average stay-at-home wife. There are many virtuous and capable women in the world, but she surpasses them all. She is a genuine wife of noble character, more precious than rubies. George can trust her, and she greatly enriches his life. She provides for all his needs and those of the family and household. Her words are wise and spoken with kindness. She is energetic and strong, a hard worker. No matter what happens, her confidence never wavers, and she never loses sight of her purpose and goal. She is the very embodiment of the Proverbs 31 woman: Let her deeds publicly declare her praise.

"Mary did it." Every time I hear that line I break down. We saw how George is often driven by fate. But once he gains experience of truth and beauty, he cannot resist desiring it, pursuing it, and living in it. At every crisis he faces, at every turning point in his life, Mary is there, she takes action, and she saves the day. George discovers that he really did have a wonderful life thanks to his wonderful wife.

Conclusion

"The good of any thing is found in its ability to accomplish what it was created for [...] to realize its purpose for existence as intended by its maker. Only in this realization can something truly be called 'good.' 'The good' is possible only in the light of truth. Not truth as it is often defined today, by personal preference or popular consensus, but truth as it is [...] independent from opinions and emotions. And where goodness and truth exist, there you will find beauty. We were created for a purpose. That purpose is not left to chance or whim, but was determined by our Maker and written in our nature. Our purpose is to seek truth, in order to discover and to act on what is good and beautiful in this life." — Hillsdale College website

In 1817, at the age of twenty-two, the English poet John Keats wrote in a letter to his friend Benjamin Bailey, "I am certain of nothing but of the holiness of the Heart's affections and the truth of Imagination—What the imagination seizes as Beauty must be truth—whether it existed before or not." Not much more than a year later, Keats traced an engraving he saw of a two-handled marble vase, and from its design and decoration he idealized the subject of his poem, "Ode on a Grecian Urn".

Thou still unravish'd bride of quietness,
 Thou foster-child of silence and slow time,
Sylvan historian, who canst thus express
 A flowery tale more sweetly than our rhyme:
What leaf-fring'd legend haunts about thy shape
 Of deities or mortals, or of both,
 In Tempe or the dales of Arcady?
What men or gods are these? What maidens loth?
 What mad pursuit? What struggle to escape?
 What pipes and timbrels? What wild ecstasy?

Heard melodies are sweet, but those unheard
 Are sweeter; therefore, ye soft pipes, play on;
Not to the sensual ear, but, more endear'd,
 Pipe to the spirit ditties of no tone:
Fair youth, beneath the trees, thou canst not leave
 Thy song, nor ever can those trees be bare;
 Bold Lover, never, never canst thou kiss,
Though winning near the goal yet, do not grieve;
 She cannot fade, though thou hast not thy bliss,
 For ever wilt thou love, and she be fair!

Ah, happy, happy boughs! that cannot shed
 Your leaves, nor ever bid the Spring adieu;
And, happy melodist, unwearied,
 For ever piping songs for ever new;
More happy love! more happy, happy love!
 For ever warm and still to be enjoy'd,
 For ever panting, and for ever young;
All breathing human passion far above,
 That leaves a heart high-sorrowful and cloy'd,
 A burning forehead, and a parching tongue.

Who are these coming to the sacrifice?
 To what green altar, O mysterious priest,
Lead'st thou that heifer lowing at the skies,

And all her silken flanks with garlands drest?
What little town by river or sea shore,
 Or mountain-built with peaceful citadel,
 Is emptied of this folk, this pious morn?
And, little town, thy streets for evermore
 Will silent be; and not a soul to tell
 Why thou art desolate, can e'er return.

O Attic shape! Fair attitude! with brede
 Of marble men and maidens overwrought,
With forest branches and the trodden weed;
 Thou, silent form, dost tease us out of thought
As doth eternity: Cold Pastoral!
 When old age shall this generation waste,
 Thou shalt remain, in midst of other woe
Than ours, a friend to man, to whom thou say'st,
 "Beauty is truth, truth beauty,—that is all
 Ye know on earth, and all ye need to know."

 The novelist Andrew Klavan wrote about this poem, "This beauty that is truth is [...] the nexus of the imagination with the eternally real." There is beauty all around us, if we only have eyes to see, ears to hear, hearts to feel.

 How can we know what we see as beautiful is beauty and what our hearts feel as truthful is truth? Emotions evoked by experience is reality, though may be impossible to describe by words. Philosopher Karl R. Popper believed that absolutely certain demonstrable knowledge is an idol. Our interpretation of facts to confirm or refute such values always contains a subjective factor. But we should not become so caught in the toils of egohood that we deny or mistrust things we cannot see or quantify. It is one thing to say that truth and beauty are hard to determine and something completely different to say truth and beauty do

not exist. If anything may be truth and anything may be beauty, then those words cease to have any shared meaning. Aesthetic standards may be fluid, difficult to articulate, and impossible to measure, but they are real and impact judgement. We can be absolutely certain that there is an objective truth and beauty because, as Popper wrote, "Only in our subjective experiences of conviction, in our subjective faith, can we be 'absolutely certain'."

Philosopher William James believed truth is a property of ideas that we can assimilate, validate, corroborate, and verify. According to philosopher Martin Heidegger, the original meaning and essence of truth in ancient Greece was unconcealment, or the revealing or bringing of what was previously hidden into the open. In some modern contexts, the word means to be authentic or faithful to a standard, in agreement with fact or reality.

Truth is an ultimate value that goes beyond fixed human conventions that serve practical purposes. While human truth cannot be found separate from subjective experience, divine truth is the objective fundamental essence of existence.

Beauty, according to David Hume, is the accumulated feelings and emotions in the mind of a person beholding an object. However, beauty as an ultimate value becomes meaningless or even unidentifiable across times and places if it is a matter of personal preference, merely existing in the eye of the beholder. That people can have differing opinions regarding the beauty of something indicates there is some standard to be found. Hume therefore allowed that experts of wide knowledge and experience are able to

debate and come to agreement on examples of beauty. Aesthetic judgements can be found to coincide to a remarkable extent. Hume concludes that "the test of time, as assessed by the verdicts of the best critics, functions as something analogous to an objective standard."

For my purposes, beauty will be considered aesthetically rather than sensually. When referring to beauty, I do not mean an object conforms to a particular mathematical ratio or definite proportions, although it will often display a finality of form or purpose of design. Beauty is an intrinsic value that, according to the philosopher Plotinus, induces "wonderment and a delicious trouble, longing and love and a trembling that is all delight".

Diana Lawrence wrote, "The power of beauty lies in its ability to elicit visceral responses, transport us to different realms, and evoke emotions that words alone cannot capture. Philosophers like Aristotle have emphasized the profound impact of beauty and its role in stimulating our senses and connecting us to the transcendent aspects of existence."

Journalist Carol Burns gives us a clue to noticing beauty: "In the end, beauty in art is a fluttering of the eye, a shivering of the skin, a shudder in the intellect. It is that moment when the soul swoons, or the heart sinks, in being, or elation, or wanderlust. A brief instant in collaboration with the senses: a glimpse of melancholy, or pulse of nostalgia. It is a movement, a pause, a glimpse, a beat."

Philosopher George Santayana believed beauty gave satisfaction to some hidden demand of our nature. He

wrote, "Beauty as we feel it is something indescribable: what it is or what it means can never be said [...]. It is an affection of the soul, a consciousness of joy and security, a pang, a dream, a pure pleasure [...] beauty is of all things what least calls for explanation."

Like Keats, William Shakespeare eloquently brought together the elements of truth and beauty, in Sonnet 54:

> O, how much more doth beauty beauteous seem
> By that sweet ornament which truth doth give!

The experience of beauty convicts us and incites a longing for truth. Literary critic Elaine Scarry wrote, "What is beautiful is in league with what is true because truth abides in the immortal sphere." We arrive closer to the mark of our appreciations when we pursue these two ideals in tandem.

Plato believed that art should focus on elevating the human spirit through the pursuit of truth and beauty. Diana Lawrence has written, "Aristotle, in his work *Poetics*, explores the cathartic nature of art and the importance of aesthetic pleasure. He asserts that beauty in art has the power to evoke emotions, stir our souls, and offer solace and escape from the complexities of life. According to Aristotle, the aesthetic qualities of art are inseparable from its ability to engage our emotions, leading to a transformative experience."

Some works of art invite the beholder to share an experience the artist had. When Pablo Picasso was poking through abandoned junk, he came across an old bicycle seat and handlebars. His mind immediately saw a head and

horns. Now, when we look at his *Bull's Head*, we share in his experience of discovery. But the truth and beauty of such found art is almost always subjective, and too often unimpressive, lacking revelation.

The 1918 painting *Venice*, by Ukrainian artist Aleksandra Ekster, is described by Richard Wess, a curator of Russian culture, as a Constructivist cityscape, combining "the elegant geometry of French Cubism with the explosive rhythm of Italian futurism. Flashes of fireworks light up the night sky. This city has gone crazy: towers, arches, palaces, bridges—they're all fluttering like flags in the wind. Here and there the outline of the winged lion of St. Mark, the patron saint of Venice, appears. What is happening to the city? Is this the famous Venetian carnival? Or, rather, has an electric current passed through this city? Will beautiful, traditional Venice survive the onslaught of a new civilization of cars and electricity? Or will it fall apart like a stage set?"

Strangely, when viewing *Venice* I experience none of those thoughts or ideas—only the second question seems applicable, for the first time I saw this painting my mind immediately made a connection to Bruegel's painting, *The Fight Between Carnival and Lent*. The arrangement and perspective of both are similar. There is color and a sense of action spread across the whole. At center is a separate blank space of calm and peace. But I see no elegance or rhythm as I do in Bruegel's masterpiece. Ekster's painting is cold, soulless, and lacking humanity. I find nothing of truth and beauty in it.

Philosopher Roger Scruton wrote, "Beauty is vanishing

from our world because we live as though it did not matter." Beauty is an assault on our self-interest and a demand to view things with reverence, creating what Scruton terms an "intolerable burden" of ideals and aspirations that conflict sharply with, rather than highlight, the tawdriness of our daily lives. What broken people cannot reach, they seek to profane and desecrate as a way to discount its meaning. Iago, in Shakespeare's play *Othello*, who states of Cassio, "He hath a daily beauty in his life that makes me ugly," so determines to destroy Cassio. Likewise, the response of many people today to an encounter with beauty is jealousy and vile transgression. Scruton continued, "The desire to desecrate is a desire to turn aesthetic judgement against itself, so that it no longer seems like a judgement of us."

The further we delve into modern and post-modern art, the more disconnected we feel. Perhaps that should come as no surprise if we pay attention to someone like abstract artist Barnett Newman, who claimed the impulse of modern art was the desire to destroy beauty. Of course, perhaps without realizing, his claim confirms there is an agreed standard value of beauty. Such values must count for something powerful to people, or they would not make such effort to offend them.

Producers of classic art approached truth and beauty with reverence, or their work did not last. *The Veiled Virgin* is a Carrara marble statue carved in Rome by Italian sculptor Giovanni Strazza sometime in the 1850s. Though chiseled of a single solid piece of stone, the veil covering the head of the Virgin Mary has the appearance of being translucent, with facial features and braids of hair still definite and clearly visible. Achieving the illusion that a

solid material like stone is actually a flowing piece of fabric clinging to a body requires a great level of skill. The technique is similar to the "wet drapery" depiction of folds in loose hanging fabric found on the *Winged Victory of Samothrace*. When Bishop John Thomas Mullock received delivery of *The Veiled Virgin*, he called it "a perfect gem of art".

Clive Bell wrote of art, "That it is a means to a state of exultation is unanimously agreed, and that it comes from the spiritual depths of man's nature is hardly contested. The appreciation of art is certainly a means to ecstasy, and the creation probably the expression of an ecstatic state of mind. Art is, in fact, a necessity to and a product of the spiritual life."

The confusion of moral revolution has obscured such ideals of truth and beauty. Modern and post-modern works are not so much art as they are propaganda. Contrast *The Veiled Virgin* with the sculpture created by Hank Willis Thomas entitled *The Embrace*. Installed in 2022 on Boston Common, the oldest continuously used public space in the United States, the work is meant to depict two pairs of arms wrapped in a hug, based on a photograph of Martin Luther King Jr and his wife Coretta Scott. The sculpture in bronze measures twenty-two-feet in height, weighs nineteen tons, and was made by welding together 609 smaller pieces.

Produced in collaboration with Embrace Boston, a nonprofit organization focused on the cause of social justice, the work is meant to honor a civil rights leader and highlight a love that helped change the world. As often as not, however, the response of critics and the public has been

mockery. Many beholders deemed the sculpture awkward, ugly, and even pornographic. Journalist Michael Brendan Dougherty wrote that "limbs, unattached to whole bodies, make for an uncanny sculptural subject. One must be told what it is to make any connection to Martin Luther King Jr." It is an abstraction of humanity and soul that even Seneca Scott, a cousin of Coretta Scott King, called an "egregious example of [...] callousness and vanity".

There is a difference between the objectively valuable and the subjectively satisfying. Truth and beauty are objective values. Taste and belief are subjective preferences. A thing of beauty is a whole, and nothing in it offends. But as modern artists continue the push to destroy beauty in art, we encounter bitterness, cynicism, and disquietude, until finally arriving at a place previously unthinkable and presently unrecognizable.

Only a week after the destructive terror in 2001 on the United States at the Twin Towers in New York City, the Pentagon in Virginia, and a field in Pennsylvania, an avant-garde musician named Karlheinz Stockhausen proclaimed those attacks "the greatest work of art imaginable for the whole cosmos. [...] Minds achieving something in an act that we couldn't even dream of in music, people rehearsing like mad for ten years, preparing fanatically for a concert, and then dying—just imagine what happened there. You have people who are that focused on a performance and then 5,000 people are dispatched to the afterlife, in a single moment. I couldn't do that. By comparison, we composers are nothing. Artists, too, sometimes try to go beyond the limits of what is feasible and conceivable, so that we wake up, so that we open ourselves to another world."

That someone could consider the deaths of thousands of people to be a work of art staggers the mind. We see from these examples, in general, modern and post-modern art lacks dignity, and without dignity there can be no truth or beauty. These aspects are (or are not) inherent in a work of art, they are not within us, a matter merely of perception. A picture of dogs playing poker may be exactly to our taste, but that does not imbibe it with truth and beauty. Personal taste is a sentiment shaped largely by cultural backgrounds, historical contexts, and individual experiences.

In his study of excellence titled *Human Accomplishment: The Pursuit of Excellence in the Arts and Sciences, 800 B.C. to 1950,* Charles Murray wrote that the "difference in quality is more than a matter of opinion" between things like a painting of Elvis on black velvet and a DaVinci. He continued, "[...] given a large number of expert opinions about a dozen specific qualities of a work of art, we will not see a random set of responses, but ones that cluster around a central tendency." This means that some works of art endure across times and peoples, while others fade into oblivion. "Excellence in the arts is defined in terms of high aesthetic quality. The combined evaluations of experts can provide a valuable measure of high aesthetic quality."

Lynne Munson, author of *Exhibitionism: Art in an Era of Intolerance,* said in an interview, "To me, so much of this is common sense—the idea that one painting can be better than another, for instance. You go to the Louvre, and there are so many people in front of the *Mona Lisa* you can barely see it. Some of that has to do with fame, of course. But ultimately that fame is the result of people over

centuries of time finding something of value in that work."

We must dig deeper beyond the mere dictionary definitions of truth and beauty. Writer Iris Murdoch described something she termed "unselfing" caused by an experience of beauty. Philosopher Simone Weil believed such an experience requires a person to give up her imagined position as the center of everything. A man may never have seen the *Winged Victory of Samothrace*, yet coming upon the monumental work in the gallery of the Louvre for the first time he is overcome with awe and wonder. That the sculpture through time has lost head, arms, and feet does nothing to diminish its impact. A woman may never have heard a piece of orchestral music, yet upon listening to Samuel Barber's *Adagio for Strings* for the first time she is overcome with tears. Though she knows nothing about a quartet, or what sounds a violin or cello make, her response is not hindered.

According to author Arthur Koestler, the essence of aesthetic experience is the intersection of intellectual illumination and emotional catharsis. The intellectual aspect constitutes a moment of truth. The emotive aspect provides an experience of beauty. "Beauty is a function of truth, truth a function of beauty. They can be separated by analysis, but in the lived experience of the creative act—and of its re-creative echo in the beholder—they are inseparable as thought is inseparable from emotion."

Experienced together, such truth and beauty produce a sensation of eternity that writer Romain Rolland termed oceanic feeling, which he explained in a letter to Sigmund Freud. "What I mean is: totally independent of all dogma,

all credo, all Church organization, all Sacred Books, all hope in a personal survival, etc., the simple and direct fact of the feeling of the 'eternal' (which can very well not be eternal, but simply without perceptible limits, and like oceanic, as it were)." He went on to note that the feeling is common to millions of people and thus subject to analysis with an approximate exactitude. "I myself am familiar with this sensation. All through my life it has never failed me; and I have always found in it a source of vital renewal."

This feeling that is common to millions of people, and thus may be readily analyzed and defined, is not disruptive, bitter, indignant, resentful, contentious, or abusive, as produced by so much post-modern art. This is instead a feeling of awe and spiritual oneness, a sacred moment of wonder that interrupts otherwise secular experiences of reality. There may be an element of surprise, of things unexpected and beyond what we might hope. We feel an expansion of self-transcending emotion that, though often inexpressible, produces stunning clarity. Philosopher and theologian Rudolf Otto termed this a numinous experience, or *mysterium tremendum*—something of overwhelming power evoked or awakened in us often independent of our will, yet merciful and gracious, different from anything else we experience in ordinary life. "The feeling of it may at times come sweeping like a gentle tide pervading the mind with a tranquil mood of deepest worship. It may pass over into a more set and lasting attitude of the soul, continuing, as it were, thrillingly vibrant and resonant, until at last it dies away and the soul resumes its 'profane,' non-religious mood of everyday experience."

Nineteenth-century French novelist Marie-Henri Beyle

wrote about his own rapid heartbeat, fainting, and feelings of confusion experienced during a visit to Florence. In her practice, psychiatrist Graziella Magherini encountered similar afflictions, and termed the condition after one of the writer's many pen-names: Stendahl syndrome, which is commonly identified as the passive suffering of patients in their minds and bodies to remarkable works of art and beauty.

Given that such recognizable experiences still occur in infinite nuance across cultures, times, and places, expressed through a broad range of art forms, there must be a certain universal source for the truth and beauty from which this syndrome of oceanic feeling arises. In his search for paradise, the great poet Dante was stunned by the beauty he saw in the eyes of Beatrice, who let him know her eyes merely reflected the splendor of what he sought. Truth and beauty are a greeting from another world.

Author Malcolm Guite wrote about the founding figures of the Romantic movement, poets Samuel Taylor Coleridge and William Wordsworth, presenting their goal as "to awaken the kind of intuitive and imaginative response to the world which allows us to explore how the outward and visible appearances of nature 'out there' can give us a whole new language of imagery and experience with which to explore what is 'in here', the whole realm of our inner experience. In other words they didn't want to divorce the 'objective' from the 'subjective' but to see them as mutually flowing between and through one another in our actual lived human experience."

Coleridge grounded his experience of truth and beauty

in a divinity that need not be dissected and analyzed but merely appreciated and celebrated. A passage in his poem, "Frost at Midnight", succinctly captures this idea:

> [...] so shalt thou see and hear
> The lovely shapes and sounds intelligible
> Of that eternal language, which thy God
> Utters, who from eternity doth teach
> Himself in all, and all things in himself.

As Coleridge explained the conception of their collaboration of poetry titled *Lyrical Ballads*, it was assigned to Wordsworth the task of showing us truth and beauty "by awakening the mind's attention from the lethargy of custom, and directing it to the loveliness and the wonders of the world before us; an inexhaustible treasure, but for which in consequence of the film of familiarity and selfish solicitude we have eyes, yet see not, ears that hear not, and hearts that neither feel nor understand."

Theologian Frederick Buechner wrote, "Pay attention to the things that bring a tear to your eye or a lump in your throat because they are signs that the holy is drawing near." When we pause to pay attention and begin to seek, our eyes and ears and hearts are opened, and we become awakened to something much larger than we can imagine. A long time ago in the biblical age, Job suffered great calamity, losing nearly everything, but in contemplation of that apparent emptiness, he knew life was not all about him, and he held tight to his immutable faith (ESV):

> "But ask the beasts, and they will teach you;
> the birds of the heavens, and they will tell you;
> or the bushes of the earth, and they will teach you;

> and the fish of the sea will declare to you.
> Who among all these does not know
> that the hand of the LORD has done this?
> In his hand is the life of every living thing
> and the breath of all mankind.
> Does not the ear test words
> as the palate tastes food?
> Wisdom is with the aged,
> and understanding in length of days."

So I've arrived at that point in my life when I begin to understand that there is truth and beauty in all creativity. While wisdom and blessing is experienced in appreciating the truth and beauty found in nature and art around us, we are called to be producers as well as consumers. Dutch theologian Abraham Kuyper wrote, "As image-bearer of God, man possesses the possibility both to create something beautiful and to delight in it."

Bird watchers experience feelings of joy and beauty when they witness a bird take flight from its nest for the first time. Before it ever hatched, it was meant to fly! We may never have seen this exact moment, or perhaps we have witnessed something similar, yet all too often we fail to note the truth in such personal experiences. What can be so obvious to us beyond ourselves can be obscured within ourselves: there is truth and beauty in our becoming who we were meant to be. Bell wrote, "How many men of talent, and even of genius, have missed being effective artists because they tried to be something else?"

Ridiculous we would be to read a novel by Proust or view a painting by Vermeer and believe those works had not a creator; so when we behold nature and all our

surroundings, we should understand these also have a Creator, and if we look close enough, we can recognize God in them.

Psalm 19 (NLT) of the Israelite king David begins:

> The heavens proclaim the glory of God.
> The skies display His craftsmanship.
> Day after day they continue to speak;
> night after night they make Him known.
> They speak without a sound or word;
> their voice is never heard.
> Yet their message has gone throughout the earth,
> and their words to all the world.

When creation shows so much beauty, how radiant must be its source! In the intersection of illumination and catharsis, at the nexus of the imagination with the eternally real, things of truth and beauty bring God before us, or, as philosopher Dietrich von Hildebrand believed, lead us before the face of God. Whether natural or man-made, these are rightly seen as expressions of the glory of God, beaming with the radiance of all creation. Aesthetic appreciation of artistic works at every moment lead us into a higher divine appreciation.

In his poem "Expostulation and Reply", Wordsworth wrote:

> "Why William, on that old grey stone,
> "Thus for the length of half a day,
> "Why William, sit you thus alone,
> "And dream your time away?
>
> "Where are your books? That light bequeath'd

"To beings else forlorn and blind!
"Up! Up! and drink the spirit breath'd
"From dead men to their kind.

"You look round on your mother earth,
"As if she for no reason bore you;
"As if you were her first-born birth,
"And none had lived before you!"

One morning thus by Esthwaite lake,
When life was sweet I knew not why,
To me my good friend Matthew spake,
And thus I made reply.

"The eye it cannot chuse but see,
"We cannot bid the ear be still;
"Our bodies feel, where'er they be,
"Against, or with our will.

"Nor less I deem that there are powers,
"Which of themselves our minds impress,
"That we can feed this mind of ours,
"In a wise passiveness.

"Think you, mid all this might sum
"Of things for ever speaking,
"That nothing of itself will come,
"But we must still be seeking?

"—Then ask not wherefore, here, alone,
"Conversing as I may,
"I sit upon this old grey stone,
"And dream my time away."

 Wordsworth repeats his friend's words in his reply, but he is not merely dreaming. He asserts the importance of observing nature over studying books. What I see him doing

is pausing in the moment, taking time to see, to hear, to feel the beauty and truth of everything around him. This poem stands out to me because it describes in a secular setting a strikingly similar situation which was captured by Vermeer in *Christ in the House of Mary and Martha*, as recorded in verses from the Gospel of Luke (ESV).

> Now as they went on their way, Jesus entered a village. And a woman named Martha welcomed him into her house. And she had a sister called Mary, who sat at the Lord's feet and listened to his teaching. But Martha was distracted with much serving. And she went up to him and said, "Lord, do you not care that my sister has left me to serve alone? Tell her then to help me." But the Lord answered her, "Martha, Martha, you are anxious and troubled about many things, but one thing is necessary. Mary has chosen the good portion, which will not be taken away from her."

How often have you, out of hospitality or inferiority or even martyrdom, allowed someone else to choose the good portion, leaving you with the proverbial short end of the stick? Jesus says that despite all of Martha's cares and worries, only one thing is necessary and worth being concerned about. We may choose the good portion for ourselves, and Jesus assures us that it will not be taken away.

Martha was always busy making sure her household fully functioned as it should; minding the details; serving others. Mary was always taking time to see, to hear, to feel life around her. Our practical side knows there are things we must do and that must be done in order for life around us to go on. Our romantic side knows we must also mind the

details of truth and beauty that are ever present, not ignore their importance and meaning, or we will cease to function fully as we should. Our task then becomes one of finding the balance between both sides, treading the narrow path between serving our mortal needs of life and feeding our immortal souls of eternity. We must be sure not to lean too far to one side or the other. We must find the time to do the chores to survive; we also must find the time to appreciate the blessings to thrive.

We may busy ourselves with many things, but only one thing is truly necessary. If we pause and step back from ourselves to look, perhaps we will notice even the mundane tasks of our daily life infused with truth and beauty, as Vermeer so expertly depicted. If we set aside our ego and become more focused on our soul, perhaps we will create moments, experiences, and places that capture the meaning of life.

All artists create in imitation of their Creator. In reference to figured song, Johannes Kepler wrote, "Man wanted to reproduce the continuity of cosmic time within a short hour, by an artful symphony for several voices, to obtain a sample test of the delight of the Divine Creator in His works, and to partake of his joy by making music in the imitation of God." In the New Testament (CSB), Paul, an apostle of Jesus Christ, writes to the church in Ephesus, "For we are his workmanship, created in Christ Jesus for good works, which God prepared ahead of time for us to do." God prepares people with gifts of wisdom, understanding, knowledge, and special artistic skills. The discoveries Kepler made and brought to light he attributed to "[...] the aid of God, who set my enthusiasm on fire and

stirred in me an irrepressible desire, who kept my life and intelligence alert [...]." The word enthusiasm comes from the Greek *en theos*, meaning 'God within'.

As creativity is a divine attribute of God, and we are created in His image, then we, too, are infused with and should embrace our own creativity. Even though a person may not have a relationship with Jesus, they can still communicate the glory of God through their creativity and sharing beauty with others, the actualization of who they were meant to be. Whether we care to admit it or not, God has absolute proprietorship in all creatures and creation. God's eternal power and divinity are clearly discernible and intelligible in and through all things that have been brought into being.

We have seen even something that the enemy might mean for evil, such as an inappropriate relationship between a composer and another woman, God can turn for good, as a means of inspiration for creating a musical work of art that, at its foundation, expresses the transcendence of love. Janáček idolized Kamila, thinking her to be the source of what he experienced. He may have been frustrated in the gratification of his worldly desires, but he did not cease in pursuit of truth and beauty that exceeded his own sanctification. Gatsby sought another man's wife as a misguided and ultimately fatal expression of values far beyond his reach. The poet Percy Bysshe Shelley wrote, "But even whilst they deny and abjure, they are yet compelled to serve, the power which is seated on the throne of their own soul."

The greatest of artists, being human, is still a sinner, still

falls far short of the perfect goodness of God. But God uses broken people for His glory. Though some consider Shakespeare to have been an adulterer as well as a homosexual, and his plays explore every aspect of humanity, from saintliness to sinfulness, his ethics are founded in and point to the good news of Jesus, convicting those with open eyes, ears, and hearts. Michael Mark, a professor of literature, wrote, "If one believes that the Holy Spirit is the author of the Scriptures, it would seem that the true originator of the dramatic method Shakespeare employs is God Himself." The breath of God can purify the moral failures of any artist and shame the world. Von Hildebrand wrote, "A work of art does not primarily make a proclamation about its author, but about the glory of the cosmos and, ultimately, about God's infinite beauty."

Philosopher Peter Kreeft has stated, "Appreciation of the good things of the world is our only possible starting point for appreciating the goodness of God." Indeed, it is the one thing that makes the bad things bearable. So it has been and still is with me. What began as a collection of essays about art and artists that I admired was soon revealed to me through the gradual guidance of the Holy Spirit as a meditation on and declaration of the glory of God. Appreciations of beauty became revelations of truth, and in the attempt to redeem things of the world by reflecting on God's handiwork, I proceeded to find meaning and create. Indeed, as Koestler wrote, "Even when my writing seems secular, it is always a process and a journey that I articulate in communion with God."

The theologian C.S. Lewis recognized that God may be discoverable everywhere. For those who wished to avoid

encountering God, he suggested, "Avoid silence, avoid solitude, avoid any train of thought that leads off the beaten track. Concentrate on money, sex, status, health and (above all) on your own grievances." To those it may be only through an experience of secular art that God is finally revealed to them. Without expecting it, the film of familiarity and selfish solicitude fall away and they begin to see anew. When I first listened to "Thing of Beauty" and other songs by Hothouse Flowers, I had a numinous experience and began to notice a subtext or a foundation of God, long before I ever became a follower of Jesus.

How shockingly natural is it to overlook God? Consider the account of the very followers of Jesus, also from the Gospel of Luke (CSB).

> Now that same day two of them were on their way to a village called Emmaus, which was about seven miles from Jerusalem. Together they were discussing everything that had taken place. And while they were discussing and arguing, Jesus himself came near and began to walk along with them. But they were prevented from recognizing him.

The disciples were so distracted by the recent events in Jerusalem—namely the arrest, crucifixion, death, and disappearance of Jesus—that they failed to recognize who walked along the road with them. Only when they came to rest at the end of the day, to take a breath from their narrative, to reflect and to pray, did they recognize the truth and beauty in their midst. I wonder how often we allow ourselves to get distracted by situations and circumstances in our life, and even news of the world quite beyond our control, and so feel overwhelmed, and lose our focus on

purpose and meaning, on anything that truly matters.

We may become preoccupied by many things, but only one thing is truly necessary. If we pause and step back from ourselves to see, to hear, and to feel, perhaps we will notice even the confusing and terrible darkness of worldly concerns cannot hide the light of God shining on us.

Picasso said, "The important thing is to create. Nothing else matters, creation is all." Humans create not out of a dark and formless emptiness—from nothing—but out of the materials, tools, and skills God has given us. Some people reject God and try to recreate the world in their own image. In such hubris we are doomed to ultimate failure. The chemist Louis Pasteur said, "The grandeur of human actions is measured by the inspiration from which they spring. Happy is he who bears a god within—an ideal of beauty and who obeys it, an ideal of art, of science. All are lighted by reflection from the infinite."

It may not be that every work of art produces in every beholder an oceanic feeling that reflects the truth and beauty of God; but I believe the oceanic feeling produced by any work of art in any beholder is a reflection of the truth and beauty of God. Koestler wrote, "In all the 'great and generous minds', from Nicolas of Cusa down to Einstein, we find this feeling of awe and wonder, an intellectual ecstasy of distinctly religious favor. Even those who professed to be devoid of it based their labors on an act of faith." Reliance on evidence as proof of discoveries requires an act of faith. The philosopher Friedrich Nietzsche wrote, "But you will have gathered what I am getting at, namely, that it is still a metaphysical faith on which our

faith in science rests—that even we knowers of today, we godless anti-metaphysicians still take our fire too, from the flame lit by the thousand-year old faith, the Christian faith which was also Plato's faith, that God is Truth; that Truth is 'Divine'."

Clive Bell theorized that a good work of art is an expression of and a means to states of mind as holy as any that men are capable of experiencing, and carries a person who is capable of appreciating it out of life into what he called pure aesthetic ecstasy. He wrote, "It is the mark of great art that its appeal is universal and eternal. [...] Great art remains stable and unobscure because the feelings that it awakens are independent of time and place, because it's kingdom is not of this world." He believed people look to great art, whether natural or man-made, for an inspiration by which to live.

Andrew Klavan wrote, "Our lives are meant to express the truth and beauty which is woven into the fabric of God's creation." When we follow the process of ideation to envisionment to ordering to expression, developing our inherent faculties of reason and imagination, we cannot help but reflect God in our act and art. Our perceptions join God's marvelous realities in works of human flourishing. This can be and is done through carving sculptures, populating spreadsheets, having babies, writing books, building houses, cultivating gardens, cooking meals, giving speeches, painting canvases, conducting experiments, teaching children, singing songs, and everything else in between.

Truth and beauty are the manifestation of God to our

senses. Proust wrote that we live according to obligations from another world, "unknown laws which we have obeyed because we bore their precepts in our hearts, knowing not whose hand had traced them there—those laws to which every profound work of the intellect brings us nearer and which are invisible only—and still!—to fools." When we pursue truth and beauty in this life and in this world, we are tracking the eternal majesty of God. In his poem "Endymion", Keats wrote, "A thing of beauty is a joy for ever [...]." Our desire to create is an imprint of the divine. When we create, we become who we were meant to be, and though still human, we experience an essence of divinity.

We bear the image of God and are imbibed with divine meaning. Ranging from the most virtuous and capable woman in the world to a deformed hermit of a man who succeeds only in his imagination, each of us has an internal capacity for love, reason, and creativity which corresponds to the trinity of ultimate values—goodness, truth, and beauty—referred to in philosophical circles as the Transcendentals. These eternal verities correspond one-for-one to morality, intellect, and emotion; service, contemplation, and praise; faith, reason, and imagination; as well as priest, king, and prophet; and ultimately to the way, the truth, and the life: Jesus Christ.

Santayana wrote, "For in the pursuit of beauty, as in that of truth, an infinite number of paths lead to failure, and only one to success." Strive as we might to appreciate and illustrate these values in this world, it is only through the redemption found in the life, death, and resurrection of Jesus Christ that humans are brought back into a right relationship and unity with God.

Though thousands of years of philosophy and religion have been based upon these values, such claims are now counter-cultural. Goodness has become situational, depending on what most benefits me. Truth has become relative, and usually confused with opinion. Beauty has become subjective, a judgement of the beholder. In our Western post-modern society, goodness, truth, and beauty have been substituted by personal philosophies. Even worse, without a firm foundation in God, these values are easily perverted into moralism, propaganda, and ugliness.

Often, as Kreeft has noted, subjective values result in pure nonsense: we should never be judgemental, except of being judgemental; and if every opinion is equally true, then the following opinion is also true, namely that opinions are not truth. Can someone truthfully claim there is no such thing as truth? Can different standards of good be known to be good? Can an artist destroy beauty if he cannot define beauty? We must not cede the objective pursuit of these verities, for then, in the words of psychologist Howard Gardner, "we resign ourselves to a world where nothing is of value, where anything goes."

There is an easy way that we know what we see as beautiful is beauty and what our hearts feel as truthful is truth. The judgements of men are mere fancy, but the doctrines of Jesus are a representation of facts as they exist in the kingdom of God. Jesus is the key by which we are able to understand and assess natural and artificial art. Jesus is the complete expression in reality and accomplishment of the truth and beauty of God. Jesus embodies what men ought to breathe, see, know, understand, and do. We may pursue a certain person who is attractive, strive after dreams

of building things, live without a care for the pleasures of today, or mortify our flesh, but it is all a mistaken desire for the truth and beauty found only in Jesus.

Ralph Waldo Emerson wrote, "Truth, and goodness, and beauty, are but different faces of the same All." Just as Jesus gave signs that point to the glory of God, so we become more like Jesus by also giving similar signs through our works of art. When we create something beautiful, though it may not have existed since God's Creation, it offers us a glimpse of eternal truth. For a moment, we are linked with divinity, enjoying direct access to God.

In a letter written just before his death, Keats lamented, "If I should die, I have left no immortal work behind [...] but I have loved the principle of beauty in all things, and if I had had time I would have made myself remembered."

Though a work of art may not directly reference God, its truth and beauty reflect Him. Scarry posited that when we experience a thing of beauty, "there simultaneously enters our minds a wish that this thing should forever be what it is now." The imagined artist of the Grecian urn sculpted a scene of beauty; Keats poetized his experience of that urn; I record my response to that ode. The moment of ancient Greece—For ever wilt thou love, and she be fair!—has been frozen and repeated through the centuries, and will continue to be so. His love never dies; her beauty never fades. In and through our creativity, we become fruitful and multiply, and others come to know the truth and beauty of the eternal divine. Though mere mortals, we are forever remembered. The idea posited by Proust's narrator that the writer Bergotte is not wholly or permanently dead is by no

means improbable. Through art we share in the glory and immortality of God.

While I was writing this book, my thoughts were guided to something the apostle Paul wrote in his letter to the Philippians (NLT): "And now, dear brothers and sisters, one final thing. Fix your thoughts on what is true, and honorable, and right, and pure, and lovely, and admirable. Think about things that are excellent and worthy of praise." When we allow ourselves time to focus on truth and beauty, we will inevitably fall into the hands of the living God, where it is our ego that suffers punishment, but our soul finds peace that passes understanding.

I pray that whatever is true, worthy of reverence, honorable and seemly, just, pure, lovely and lovable, kind and winsome and gracious, virtuous and most excellent, you will think on and weigh and take account of those things, and the truth and beauty of the Lord our God reflect upon and shine through you.

Appreciations of Truth and Beauty

"It is true, indeed, that appreciation is a very real activity, and I believe that it is in fact an activity of discovering in Art or in Nature the kindred spirit of the Artist (Divine or human) there self-expressed." — William Temple

About the Author

Jeffrey K. Hill is a writer from Illinois who uses his passions and skills to share the truth and beauty of God. His fiction focuses on love, loss, and the varied affairs of the heart. His non-fiction focuses on faith, history, and American exceptionalism.

Available Now

Fiction

Marie Stuart, Queen of Hearts
by Jeffrey K. Hill Copyright © 2022

Tales of Mystery and Truth
by Jeffrey K. Hill Copyright © 2013

The Secret Marriage Vows
by Jeffrey K. Hill Copyright © 2013

The Triumphs
by Jeffrey K. Hill Copyright © 2012

The Beggars of Azure
by Jeffrey K. Hill Copyright © 2012

The Last Courtesan
by Jeffrey K. Hill Copyright © 2012

The Last Decadent: A Novel Of Paris
by Jeffrey K. Hill Copyright © 2011

Non-Fiction

Miracles in Broken Pieces
by Jeffrey K. Hill Copyright © 2016

Safeguarding American Ideals
by Harry F. Atwood and Jeffrey K. Hill Copyright © 2013

Harry F. Atwood Speeches
by Harry F. Atwood and Jeffrey K. Hill Copyright © 2013

Columbia: America Personified, and Other Essays
by Jeffrey K. Hill Copyright © 2012

Keep God in American History
by Harry F. Atwood and Jeffrey K. Hill Copyright © 2011

Poems for Patriots
Edited by Jeffrey K. Hill Copyright © 2011

Quilldrivers works of fiction, literature, faith, and history are available at Amazon and through Quilldrivers.com

Colophon

Appreciations of Truth and Beauty
by Jeffrey K. Hill
Copyright © 2024
First Edition
ISBN: 9798345668740

Scripture quotations marked (NLT) are taken from the *Holy Bible, New Living Translation*, Copyright © 1996, 2004, 2007. Used by permission of Tyndale House Publishers Inc., Carol Stream, Illinois 60188. All rights reserved.

Scripture quotations marked (CSB) have been taken from the *Christian Standard Bible®*, Copyright © 2017 by Holman Bible Publishers. Used by permission. Christian Standard Bible® and CSB® are federally registered trademarks of Holman Bible Publishers.

Scripture quotations marked (ESV) are from the *Holy Bible, English Standard Version*, Copyright © 2001, 2007, 2011, 2016 by Crossway Bibles, a division of Good News Publishers. Used by permission. All rights reserved.

"Composer of Love Notes" and "Apostle of the Infinite" appeared previously in an earlier form in the book *Columbia, and Other Essays* (2012). *One Hundred Years of Solitude* appeared previously in an earlier form in the online

journal *Margin* (2003). All other quotes and excerpts not the author's are attributed and considered to be either in the public domain or recognized as fair use for the purpose of critical analysis.

Cover detail from *The Milkmaid*, by Johannes Vermeer, ca. 1660. Public domain CC PDM 1.0.

This digital book is licensed for personal use only. This digital book may not be resold, redistributed, or given away to another user. If you would like to share this book with others, individual copies must be purchased for each user. Thank you for respecting the author's work.

Quilldrivers

www.ingramcontent.com/pod-product-compliance
Lightning Source LLC
Chambersburg PA
CBHW070423240526
45472CB00020B/1175